Painting In Mixed Media

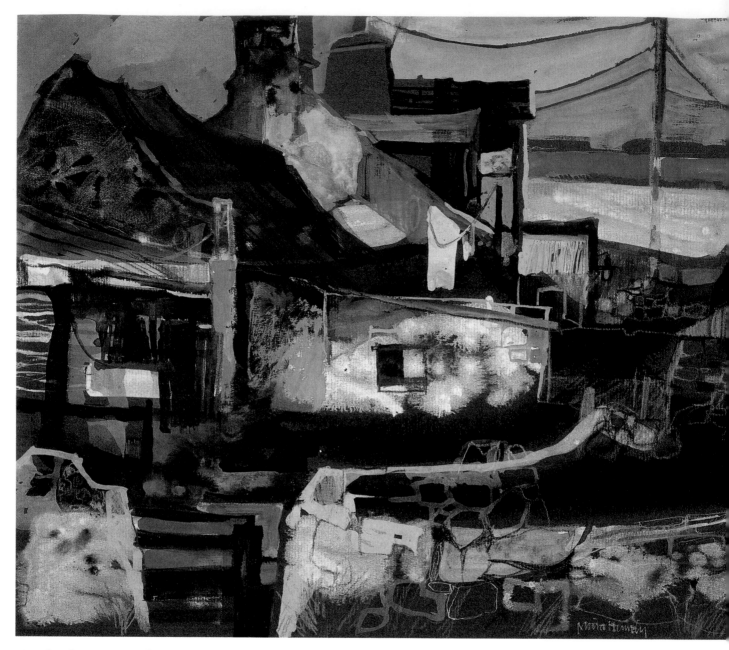

Pembroke Farm with Blue Paint 12″ × 14½″

Painting In Mixed Media

Moira Huntly

North Light Books

Cincinnati

© 1989 Moira Huntly
(Painting on page 101 © John Blockley)

First published 1989
A & C Black (Publishers) Limited
35 Bedford Row, London WC1R 4JH

ISBN 0–7136–3167–8

A CIP catalogue record for this book is
available from the British Library.

Simultaneously published in the U.S. by:
North Light Books
an imprint of F & W Publications, Inc.
1507 Dana Avenue, Cincinnati,
Ohio 45207

ISBN 0–89134–302–4

Typeset by August Filmsetting,
Haydock, St Helens, U.K.
Printed in Singapore by Singapore
National Printers Ltd

Contents

Illustrations

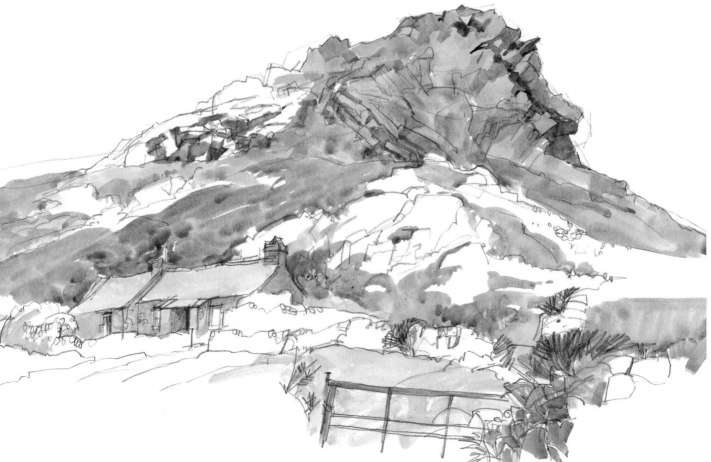

Cottage at Strumble Head

Pembroke Cottage

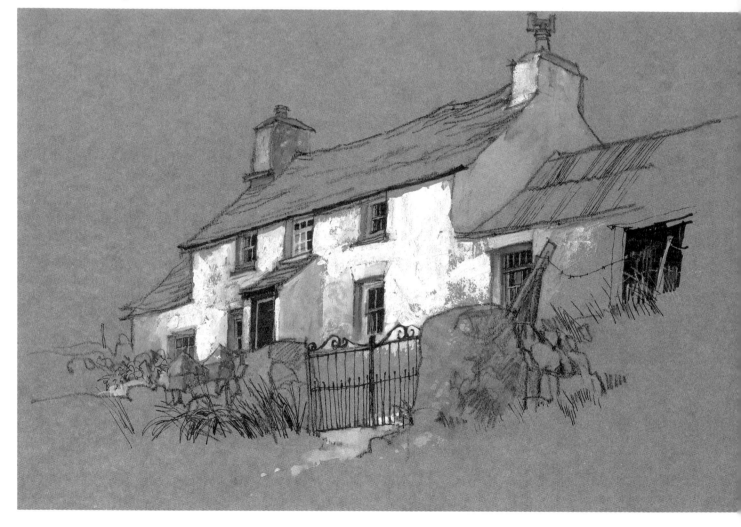

Introduction

Painting in mixed media is not a new concept. Few of us are real innovators, but we may all benefit by studying some of the methods employed by our predecessors. Many of the ideas put forward in this book are based on the sound techniques of past masters who used combinations of media. Their original techniques have stood the test of time, but are nevertheless adaptable to our own individual vision of painting today – with the excitement of experimenting with recent additions to the range of artists' materials, such as acrylic paint and oil pastels.

A wide choice of media is now available and there are no rules other than the practical limitations of each medium and their technical compatibility.

The idea of combining different media within one painting is stimulating; it offers the prospect of making new discoveries, increasing our conception, and generally extending ourselves as painters.

The art materials I have introduced into this book are not in themselves complicated. They include watercolour and gouache, charcoal, pastel pencils and soft pastels, oil paint and oil pastels, ink, candle wax and wax crayons. The paintings and drawings in the book, described in some detail, are mainly combinations of not more than two or three of these media, but an important further element in the painting lies in their chosen support. Such choice can greatly enhance the effect of mixed media, and this is well illustrated in the painting 'Pembroke 'Farm with Blue Paint' (page 2) where I used three different media – ink, gouache and pastel pencils – and allowed much of the coloured support (a dark green Ingres paper) to show through and play a part in the final image.

The way in which the 'Pembroke Farm' painting was evolved was quite unusual, in that it began in the studio as an abstract experiment and was completed later from an actual subject on location. Normally, I work the other way round, making sketches on location which form the basis of subsequent studio paintings. Certainly, a Pembroke farm was not in my mind when I began my abstract experiment, for I had no thoughts of any actual subject but was merely experimenting with the ways in which black and white ink could be distributed at random.

On some areas of the paper I painted with dilute ink, on others I tried dropping it 'wet on wet', observing how the ink would spread and diffuse and sometimes leave a granular effect. At this stage I had an abstract patchwork of black and white ink on a dark green background and it was purely coincidental that, in the afternoon, in a small Pembrokeshire village, I came by chance across some farm buildings which I immediately perceived to have many of the visual elements in my earlier abstract experiment. The final painting was completed on location, the first ink images being adjusted to suit the subject and the subject being adapted to fit the abstract shapes. By refining some of the ink work with the addition of gouache and drawing with pastel pencil, I aimed to capture the spirit and sense of the place rather than produce a copy of the scene. As a result of using mixed media, together with an appropriate support, the painting depicts the particular rough texture of the stonework and lichen and the reflection and sparkle of natural light.

But mixed media are by no means confined to the more abstract paintings; they can be equally effective in enhancing a literal treatment of a subject. On another occasion, still in Pembrokeshire, I made a representational drawing of what was in front of me on location, using at this time a conté pencil and ink on mid-toned paper heightened with white gouache (page 8).

Once the idea of mixed media takes hold the painting scope is widened, ideas develop, and an awareness of colour, tone and texture can be increased. A mixture of media can create a varied and often rich surface; sometimes a particular needed texture can only be obtained by continually experimenting with a variety of media. This inventiveness extends our vision and so expands our development as painters. Our experiments may sometimes take us in unexpected directions, full of promising shapes or textures, and it is good to make full use of happy accidents that may occur.

I often start a painting in abstract terms, placing big shapes and looking for rhythms and movements within the composition before developing the more literal aspects of the subject. This way of working enables me to dictate the arrangement of the parts within the painting, rather than allowing the realistic depiction of a subject to dominate its composition.

Today, interpretations can be more flexible, for it is now more readily acceptable to represent natural subjects in less obvious ways than in previous centuries and we can create visual images with a greater variety of methods and materials. Using a non-representational method, for example, to portray a representational subject, can create a fresh approach; the interplay between the various media can provide the eye with an unexpected excitement.

In this book I have suggested ideas for further development that may eventually become incorporated into your general painting. My aim is to stimulate and encourage new lines of thought and to further your interest in the experimental use of mixed media.

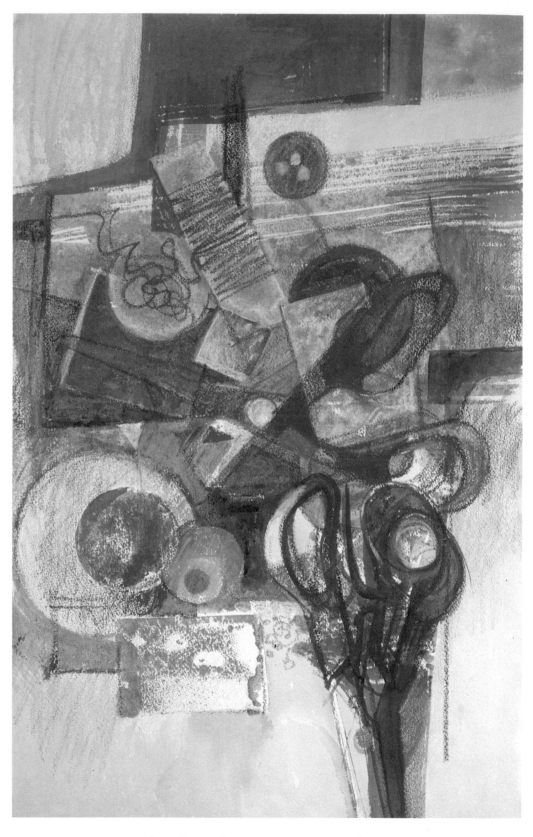

Sewing Table $22'' \times 13\frac{1}{2}''$

This painting was made with water-colour, candle wax, gold oil pastel and coloured wax crayons.

I aimed to make an almost abstract pattern of simple shapes within which some indications of scissors, cotton bobbins and sewing paraphernalia are only just evident.

Wax and watercolour

Watercolour and wax (in the form of a candle) are basic materials that most artists and students possess and so I have chosen this combination as a simple introduction to the idea of mixed media. The effect when watercolour is washed over a hitherto invisible candle wax scribble is always a delight to behold and I like to think of the results as 'magic' pictures!

The paintings in this section begin by drawing with wax on white paper, and then washing over the paper with watercolour. In effect, the candle or wax crayon when applied to the paper creates a resist. When watercolour is brushed over it, only a few small beads of colour adhere to the waxed surface, and the drawing will appear as white paper.

The drawback with this technique is that wax, once applied, cannot easily be removed so the first areas of wax should be considered carefully. There is also a visual difficulty related to the use of colourless candle wax, in that white wax on a white paper cannot easily be seen. However, it is just possible to see a waxed area if you hold the paper up to eye level and look along the surface, tilting it until the light shines on the wax.

It is advisable to make some experiments on a spare piece of paper to find out how much pressure is needed to deposit the amount of resist you require. If too much wax has been applied it can be remedied to a certain extent by scraping off with a razor blade, or by placing your work between two or three layers of absorbent paper and applying pressure with a warm iron. An area of unwanted white wax can also be modified by working over it with coloured wax crayons. The visual difficulties mentioned earlier are, of course, eliminated when using coloured candles and crayons, but they lack the touch of excitement that comes when a wash of watercolour suddenly reveals a pattern of colourless wax, as if by magic.

This magical appearance is shown in *Fig. 1*, where the wash is beginning to make my wax doodle appear, and *Fig. 2* completes the image. When a wash is completely dry, more candle wax can be applied if desired, and a second wash of a different colour can be brushed over. The first colour wash is seen through the second application of wax and the first layer of wax remains, showing the white paper. An example of this can be seen in *Fig. 3*, and it is a process which can be repeated several times.

Fig. 1

Fig. 2

Fig. 3

Fig. 4

Fig. 5

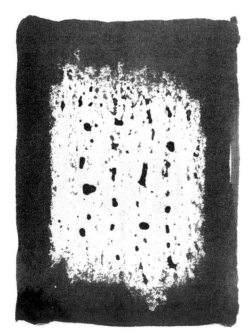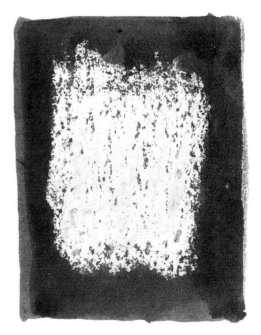

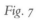Fig. 7

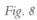Fig. 8

The kind of support you use plays an important part in the visual effects of the resist. In *Fig. 4* a heavy 400 lb rough watercolour paper has been used, the wax has adhered to the surface of the grain to give it a strongly textured result, whereas in *Fig. 5* the smooth cartridge paper has taken wax more evenly and given a greater definition.

For *Fig. 6* I used a piece of 90 lb Whatman watercolour paper which gave a moderately textured effect somewhere between the two extremes of paper shown in *Fig. 4* and *Fig. 5*. For this more elaborate doodle I found it easier to start by indicating the preliminary areas of clear candle wax with a faint pencil line. Then I proceeded with the application of candle wax followed by the first wash. This course of action was repeated with up to three successive washes.

Fig. 7 White candle wax was applied thickly onto smooth white paper and a dark wash of Prussian green brushed over. There was less water and more pigment in this wash and some of the colour became trapped in the granular texture of the wax, giving an interesting speckled texture.

Fig. 8 The same wash was brushed over an identical area of candle wax and here the beads of pigment trapped on the wax were gently blotted with a clean rag. This has the effect of softening the texture and subduing the colour.

Fig. 6

Coloured wax crayons with watercolour

The introduction of coloured wax widens the scope and extends the possibilites of interesting effects that can be produced in a watercolour and wax painting. *Stages 1–3* of my 'doodle' show the basic techniques of overlaying watercolour washes and coloured wax as shown in the demonstration 'Cut Apples on a Plate I' on page 16.

Coloured wax can also be applied on top of clear wax; further layers can be built up and then scratched into with a razor blade.

Stage 1 A 'doodle', using green wax crayon.

Stage 2 A wash of lemon yellow watercolour was brushed over the green wax. When this was dry, I applied red wax crayon in parts.

Stage 3 This shows a wash of purple watercolour in the process of being applied over the wax parts of *Stage 2*.

These doodles are helpful and fun to do, and they give an idea of what can be achieved by overlaying watercolour washes and coloured wax.

Drawing of Cut Apples

(cartridge paper, green pastel pencil, black conté pencil)

My drawing of cut apples formed the basis for paintings in wax and water-colour. The drawing portrays a natural subject in a representational way, but in the act of drawing my awareness of the abstract qualities of the subject was intensified. Individual pieces of apple had fallen into a hap-hazard arrangement as they were cut, yet their shapes had a unity, perhaps because each piece was originally part of a whole, and consequently the vari-ous segments and planes of the cut apples had similar curves and angu-larities.

Subtle curves, with occasional sharp angles, texture of cut surfaces, and the pattern of apple seeds revealed within the core, all hold a continual fascination for me and the subject has inspired several paintings. The strong-ly abstract character that I am consc-ious of with this subject has led me quite naturally to diversify into mixed media. For my painting 'Cut Apples on a Plate' overleaf the granular quality of the cut surface of an apple segment led me to use a wax and watercolour technique.

Wax, watercolour and wax crayons

Cut Apples on a Plate I

(Bockingford w/col paper (140 lb), candle, wax crayons, round sable brush no. 10, watercolours: aureolin, cadmium orange, Hooker's green)

Many of the techniques already illustrated have been employed in this painting. Before commencing to paint, a little thought was given to the arrangement on the paper. I asked myself questions: should the plate be placed in the centre of the painting, or would the composition be more satisfactory if the plate occupied an off-centre position?

I decided to choose a 'right of centre' position, and balanced this with a rectangle in the top left corner. I felt that a central position for the plate would have created a large space on the right, and the cut apples on the left would have appeared crowded and uncomfortably close to the edge of the paper, this resulting in an unbalanced composition.

Stage 1 With the arrangement in my mind's eye, I took up a large brush and some aureolin yellow watercolour and quickly placed the objects, filling in some areas with solid colour. I consider aureolin to be a very exciting zingy kind of yellow, and when the wash was dry, I used a vibrant coloured orange wax crayon to firm up on the drawing and put some texture on the fruit. Colourless wax candle was rubbed over the edge of the plate and over some of the cut surfaces of the apples. For demonstration purposes only, I brushed pale Hooker's green over two areas in order to make the wax visible, the main green wash was not being introduced until a later stage in the painting. The second colour was cadmium orange, and a strong wash was superimposed on the yellow cloth and on some of the fruit.

Stage 2 After the orange washes had dried, candle wax was rubbed over the surface of the cloth on some parts; applied with squiggles and dots on others, and also onto the orange fruit on the plate. Blue wax crayon was introduced onto the left corner, and then a pale wash of Hooker's green was painted over all the apples, part of the background and the cloth, and was repelled by those surfaces which had been waxed.

Stage 3 (final) A darker wash of Hooker's green was painted over most of the background, the apple skins, and the cloth. The original orange of the cloth could now only be seen through the candle wax scribbles and rubbed areas. The drawing of the apples and plate was re-defined with dark green wax crayon and a deep turquoise crayon was used on some of the cut surface and on the cloth. Dark tones were added with washes of ultramarine and indigo watercolour, and finally a touch of detail was added to the stalks and cores of the apples with watercolour and a pen.

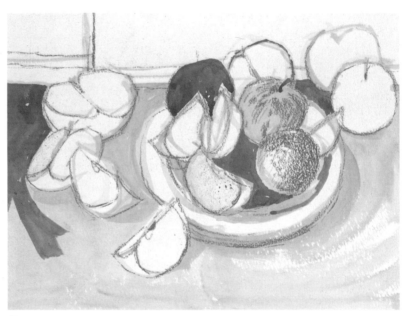

Stage 1

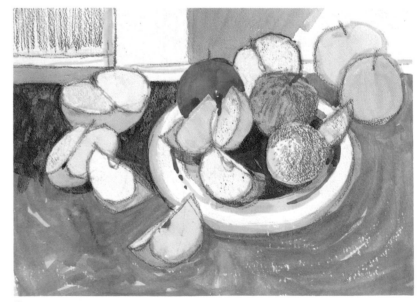

Stage 2

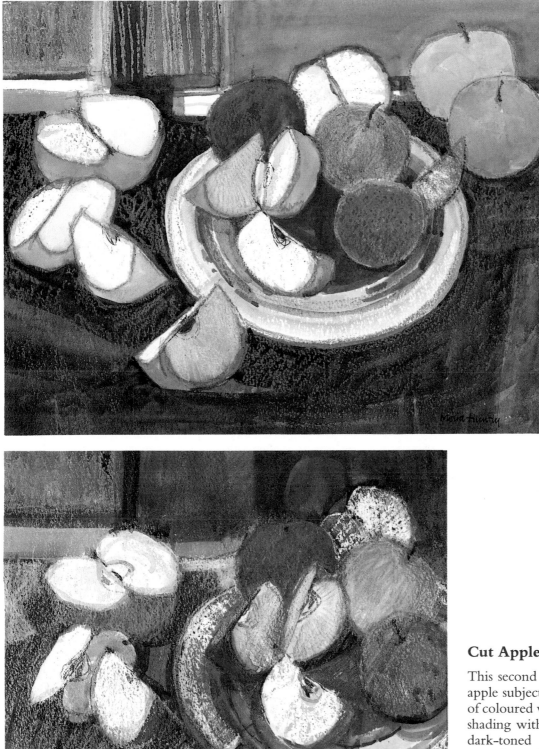

**Cut Apples on
a Plate I** $10\frac{3}{4}'' \times 15''$

Cut Apples on a Plate II

This second interpretation of the cut apple subject explores further the use of coloured wax crayons. Some of the shading with blue and purple is over dark-toned watercolour, and some areas have been lightened with the introduction of an opaque white wax crayon. This creates a different effect as an alternative to masking with clear candle wax. Light areas on the rim of the plate and on some cut surfaces of the apples have been achieved by scraping back to white paper through the layers of coloured wax.

Cut Apples on a Plate II $10\frac{3}{4}'' \times 11\frac{1}{4}''$

Rubbing techniques with wax crayon

Different textures can be obtained by placing a piece of moderately thin paper over an incised or uneven surface.

Black or coloured wax is then rubbed onto the paper and the uneven surface underneath appears as a textured image.

Fig. 1 Shows the effect of rubbing black wax over a piece of heavily textured wallpaper.

Fig. 2 A rubbing over the surface of a brick.

Fig. 3 Rubbing over strips of cut paper.

Fig. 4 Rubbing over torn paper.

Fig. 5 Making marks with the long edge of the crayon.

Fig. 6 Scratching with a razor blade through two layers of wax crayon.

Fig. 7 The stones by the water's edge have been drawn with wax, and a rough-surfaced wallpaper was used beneath the textured area of the ground. Grasses have been indicated by stabbing at the paper with the long edge of the crayon and, finally, a light wash of raw umber watercolour was added.

Fig. 8 Rough wallpaper was also ideal to suggest the textured wall on the face of this building. Light washes of watercolour have been added over the wax drawing.

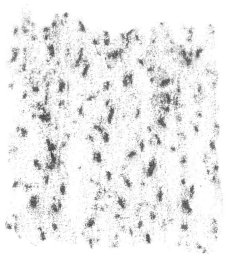

Fig. 1

Fig. 2

Fig. 3

Fig. 4

Fig. 5

Fig. 6

Stones by the Water's Edge

Farm Building

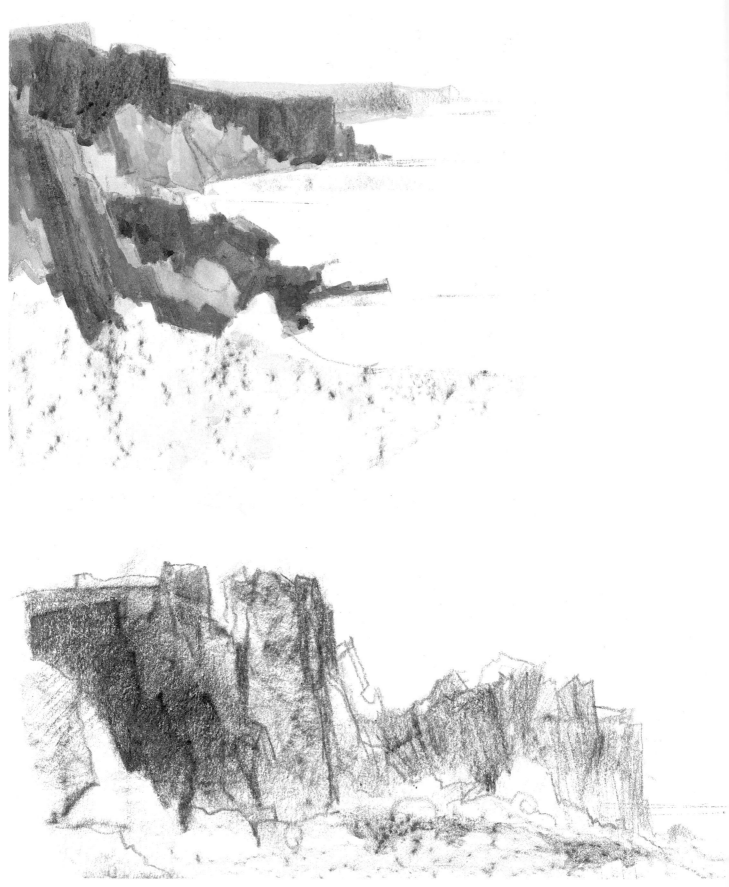

Cliffs and Coast

Black wax crayon and watercolour

Rock Faces

Some of the rubbing techniques already discussed seemed ideal for depicting the various textures to be found within coastal subjects.

To this end, for the subsequent rubbing effects, I prepared some small pieces of card, tearing some into shapes to achieve uneven edges and cutting others with scissors to give sharper, more precise edges.

First, I drew an outline of the coastline with a black wax crayon. Then I arranged some of the card shapes underneath the paper and started to rub gently, using the side of the crayon across the surface below the outline of the rocks. This produced the first cliff edge shapes, and this process was repeated several times, moving the shapes about underneath the paper quite randomly. The speckled texture in the foreground was produced by rubbing over a piece of rough wallpaper.

My second sketch of a coastline employs identical techniques, using a black wax crayon, but with the addition of watercolour washes to provide colour notes.

The third rendering of a coastal subject has taken the watercolour washes and black wax shading further, thus making a more complete tonal statement.

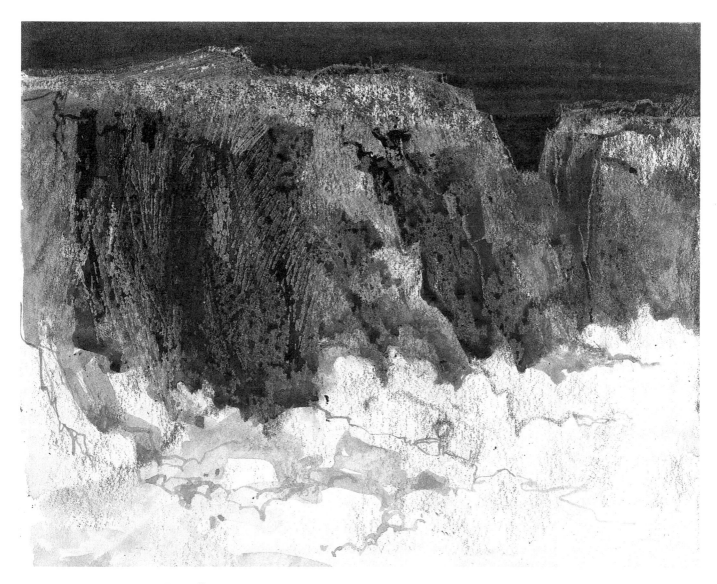

Cliffs and Storm Sky $5'' \times 6\frac{1}{4}''$

Wax, watercolour and wax crayon

Still Life with Spiky-leaved Pot Plant I

Predominantly watercolour, with some textural effects added with candle and blue, yellow and green wax crayons.

Still Life with Spiky-leaved Pot Plant II

Predominantly wax crayon (blue and orange) applied to white paper – in some areas by a rubbing technique where different thicknesses of card were placed underneath the paper. This was followed by washes of vermilion and indigo watercolour.

Finally, some areas of wax were scraped off with a razor blade to reveal the light tone of the paper underneath.

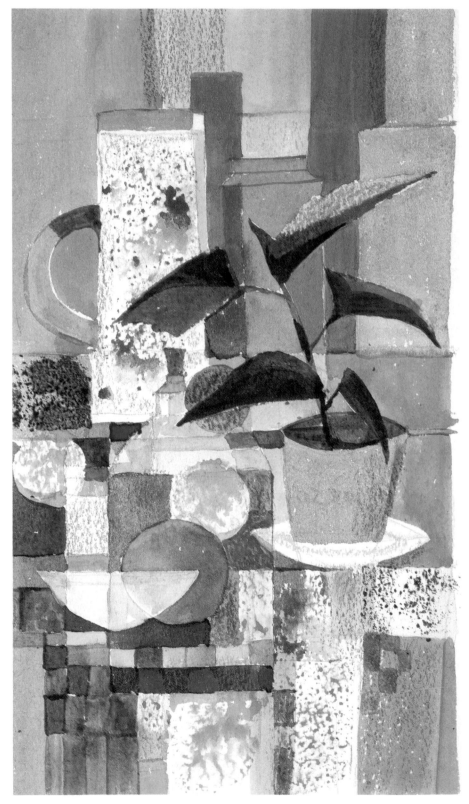

Still Life with a Pot Plant I
$9'' \times 5\frac{1}{4}''$

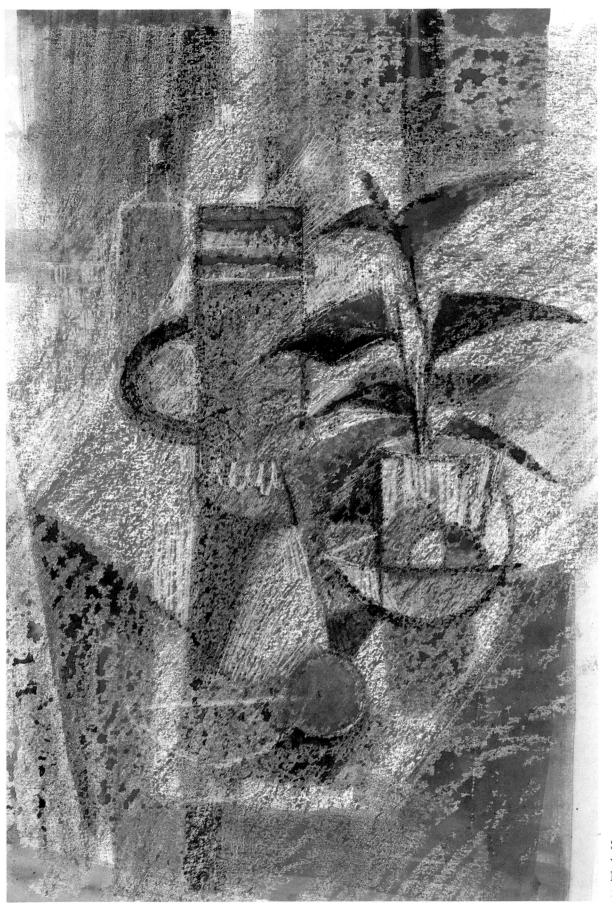

**Still Life
with a
Pot Plant II**
$11'' \times 7\frac{1}{4}''$

Eggs 10″ × 5½″

Watercolour and pastel

Pastel and watercolour have totally different characteristics, and so their combination in a painting can create some very interesting images. On one hand we have the transparency and smooth-surfaced washes of watercolour, contrasted with the opaque, sometimes heavily textured effects that can be obtained with pastel by rubbing or brushing it across the surface of the paper, in which process it retains much of its opacity.

My doodles show various methods of combining watercolour and pastel, and in the painting 'Eggs', shown opposite, several of these techniques have been employed. Light-coloured pastel has been drawn onto dark washes; dark-coloured pastel onto a dark wash to increase further the depth of tone; and pastel has also been applied directly to the white support, being sometimes rubbed into the surface. The rough quality of the support is of primary importance in this painting, where I wished to achieve some rich textural effects. In this case the support was a piece of 500lb watercolour paper, almost a board. I found that pastel applied to such a surface resulted in a pronounced texture.

These techniques with watercolour and pastel offer interesting possibilities for making finished paintings. I also find the combination very effective when I am trying out rough ideas for lithographs. Lithography is a rather involved print-making process, but the finished print has a distinctive quality, often combining flat areas of colour with drawn and textured areas. Watercolour and pastel can give a similar impression.

Fig. 1

Fig. 2

Fig. 3

Fig. 4

Doodles

1. A dark watercolour wash contrasted with pastel drawing.

2. An all-over wash of dark watercolour. When it was dry a light tone of pastel was applied on top and then rubbed into the wash to give a diffused effect.

3. Dark and light pastel were cross-hatched over watercolour washes of varying tone and colour.

4. Pastel was applied to the paper and left unfixed. Watercolour was brushed over, causing the pastel to diffuse and partly mix with the paint. Thick areas of pastel can sometimes repel the water in a similar way to a wax resist.

25

Watercolour and pastel

It is usual for me to begin most of my painting by making a broad exploratory underpainting with a large brush and dilute pigment. After this initial paint has dried out, I gradually superimpose increasingly thicker pigment as the painting progresses. This sequence of working will be familiar to oil painters, who will recognise it as a 'fat on lean' process, but the method can also be applied to a combination of watercolour and pastel.

I like to construct a composition gradually and establish the main areas of tone, and for this I find that an underpainting using watercolour works well on a light or mid-toned pastel paper. It would not, however, be practical to employ this method on a very dark-toned paper, since the watercolour would not easily be seen.

Some pastel paper has a pronounced texture which can be distracting if it breaks into an area of dark pastel. This effect can be controlled on a light-toned paper by painting dark areas with dark watercolour. Not only is there a sound practical reason for employing a process of underpainting; it also provides a visually interesting result.

Fig. 1

Fig. 2

Fig. 3

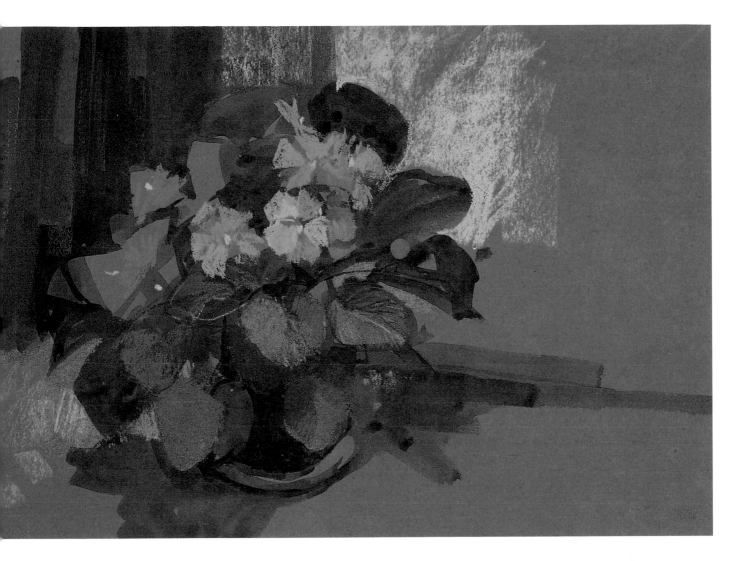

Techniques

Fig. 1 A dark-toned wash of water-colour is brushed onto light-toned pastel paper and allowed to dry. Light-coloured soft pastel is applied on top of the watercolour with varying pressure. Where the pressure is gentle, the dark wash shows through and a texture is created, whereas a heavy application of pastel can totally cover the underlying wash if desired.

Fig.2 The cottage and mountain are indicated with watercolour. When this is dry the sky is painted with a light tone of pastel. The initial washes can be very loose and free since the shapes can be re-defined by the subsequent application of opaque pastel. Some lighter passages are then applied with pastel to the cottage and mountains.

Fig. 3 This shows the early stages of a painting where watercolour has been used as the 'lean' underpainting and pastel is applied on the stonework and window ledges, representing the 'fat' paint. The surface characteristics of the mediums are different, but the principle of 'fat on lean' is the same as that employed in the oil painting method.

Picture above The colour choice of the paper used bears a strong influence on the final painting. Here, on my African violet, an underpainting of ultramarine blue watercolour on bright orange pastel paper, combine optically to make a brownish purple. Pastel is applied on top to allow both the underpainting and warm paper to show through in parts and permeate the painting.

African Violet $9\frac{1}{2}'' \times 11\frac{1}{2}''$

Watercolour and pastel

Pink Cottage $10\frac{1}{2}'' \times 9''$

Here again, I start the painting on a light-grey pastel paper, with watercolour and a brush. There is no need for a preliminary pencil drawing, any alterations in the positioning of the subject that may subsequently be necessary can always be carried out at a later stage, when pastel is applied.

The soft watercolour washes that underlie the pastel areas in this subject set a gentle key for the painting.

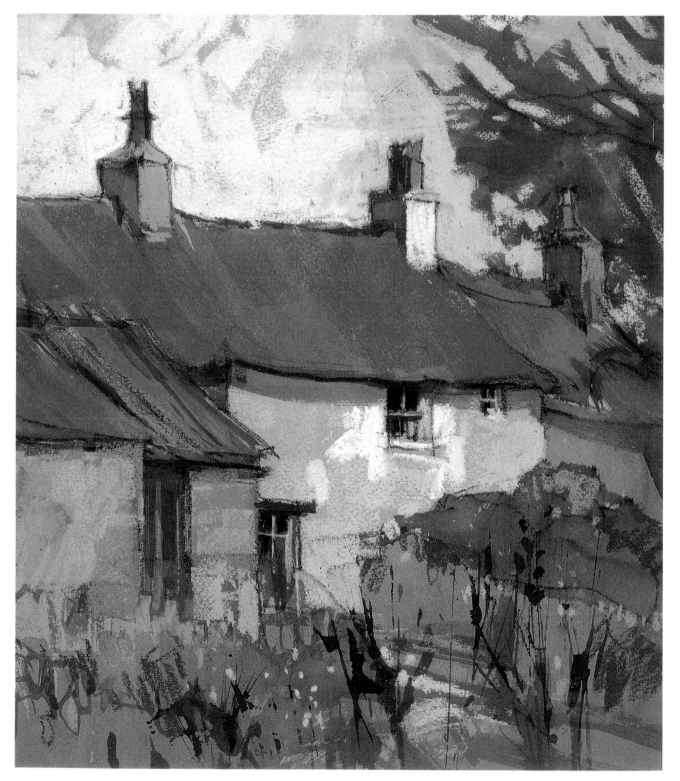

Covent Garden 21″ × ′18½″

Loose, colourful washes of red, green and blue watercolour are applied to a light-grey paper. Then the subject is drawn with pastel pencil and light tones applied on top with pastel, vary-ing the pressure to allow some of the colour to show through. Parts of the wash are left without pastel, their matt quality acting as a nice foil to the tex-tured areas of pastel.

Watercolour and pastel

Still Life with Tall Pot, Teapot and Fruit

(mid-grey Canson paper, conté pencil, watercolour, pastel)

This still life with the large pot explores further the methods of painting with a combination of pastel and watercolour. This time the painting starts with watercolour, pastel is applied on top (as before) and then the pastel is partly washed over with watercolour. These final washes wet the pastel and thus impart a different character to the pastel surface.

The subject was singing with the brilliance of the fruit, and the bright orange colour of my favourite teapot contrasted with the turquoise of the wall behind.

Stage 1 The paper had been previously dampened and stretched onto a board and time allowed for the surface to dry. I made the initial drawing with a dark-grey conté pencil, keeping the line work loose and free, and then commenced painting in a more disciplined way with a tonal underpainting in watercolour. The first washes were a fairly dilute mixture of burnt umber and ultramarine which can be seen on the fruit and teapot; the background and large pot were painted with a less dilute mixture which resulted in a darker tone. Finally I completed the underpainting, making the bottles very dark in tone by adding a touch of Hooker's green and more burnt umber pigment to the mixture. All this was stated quite speedily with a $1\frac{1}{2}''$ wide house painter's bristle brush.

Stage 2 Strong colour was added with pastel onto the areas catching the light and onto the background. In the process of overpainting the background with pastel. I re-defined the drawing of the large pot. The bottles on the right-hand side were also defined and became strongly silhouetted darks against the light pastel background.

Stage 3 Despite the brilliant warm oranges of the teapot and fruit I felt that the painting could be biased towards a cooler blue-green interpretation. To this end I took up a large soft brush full of Prussian blue watercolour and, with some trepidation, swept the wash lightly downwards over the painting. I must admit that it required a certain amount of courage to paint over the areas of pastel and to risk ruining the painting at this third stage, in the hope of achieving a greater degree of subtlety and blending together of colour and tone. It did, however, help to unify the painting. The bottles to the right of the big pot, for example, no longer have strong silhouettes against a light background; tonal changes have become less obvious, and some of the strong colours have blended into the dark areas.

A thick layer of pastel will resist watercolour, as does wax, and a thinner layer of pastel will partly mix with the watercolour as the brush passes over it. This mixing changes the surface quality and tone of the pastel to give a matt, almost bland, effect when it has dried out. It should also be noted that pastel applied onto a wet surface will immediately appear to be darker in tone, but as it dries the tone gradually lightens. As the damp brush passes over the areas of pastel some particles will adhere to the bristles and then be deposited on another part of the painting. Thus hints of orange appeared on the right-hand bottle and on the background, and touches of turquoise were transferred onto the apples. I call these 'happy accidents', and I look out for them and incorporate them into the painting if they are valid, and adjust any unwanted deposits of pastel by brushing them out with another wash of watercolour.

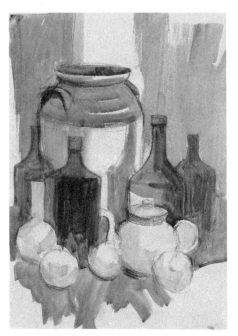

Stage 1

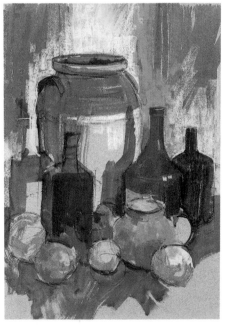

Stage 2

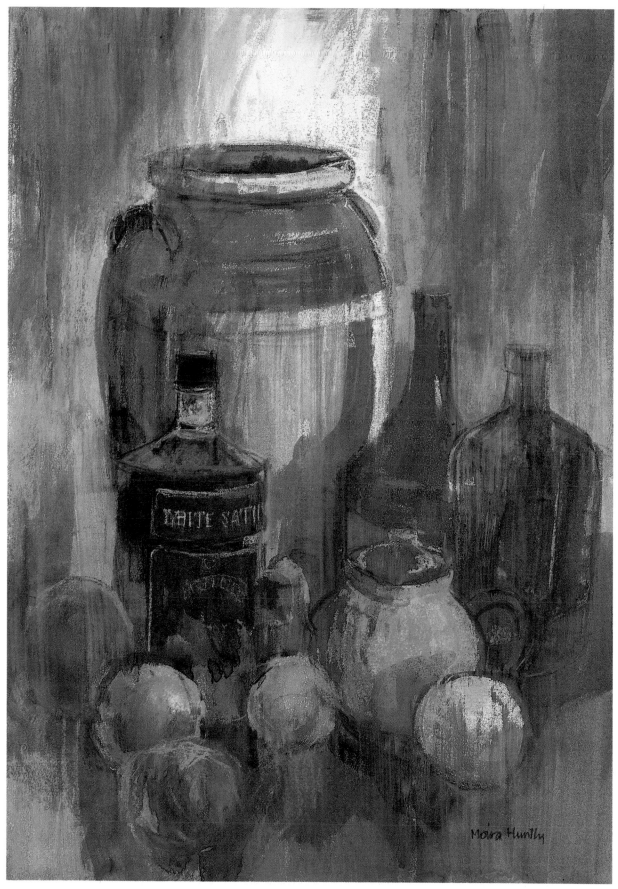

Still Life with Tall Pot, Teapot and Fruit 21″ × 14½″

Watercolour and pastel pencil

Sketches

Pastel in the hardened form of a pastel pencil is a swift and sensitive sketching tool, especially suited to those of us who like to work broadly in a large sketchbook. The combination of pastel pencil and watercolour is one that works well in providing a quick and comprehensive amount of information in a sketch whch can be used as reference for a subsequent painting. It is also versatile, in that the pastel pencil can be used to sketch the subject with a simple outline, establishing the proportions and general arrangement on the paper before the tones are recorded with watercolour. The watercolour can be kept to a monochrome or alternatively, a pastel pencil drawing can be taken further than an outline, and shading used to indicate tones and textures. A subsequent wash of watercolour over the sketch, to record the colour, will not detract from the drawing in any way. On the contrary, the drawing can be seen through the transparent washes and blends well with watercolour.

In the coastal sketch made amongst the rocks, I wanted to record how the sea and wind had bleached the driftwood almost white. To achieve this I let the driftwood remain as white paper and painted the sky with dark blue watercolour as a contrast. Most of the sketch was made with a black pastel pencil, but in addition to the watercolour, soft grey pastel was used to describe textures on some of the rocks.

It is advisable to use a fixative spray on all pastel drawings, especially if they are in a sketchbook where there is a danger of one drawing off-setting onto another.

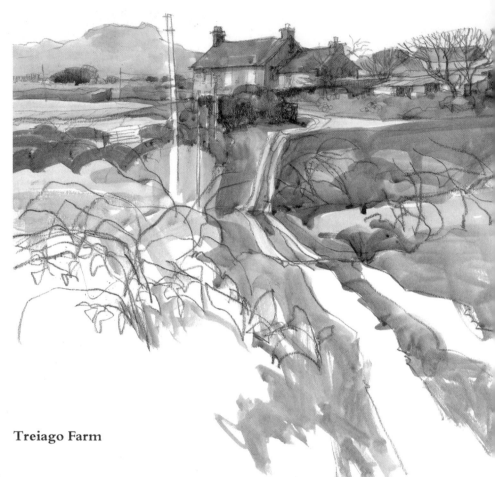

Treiago Farm

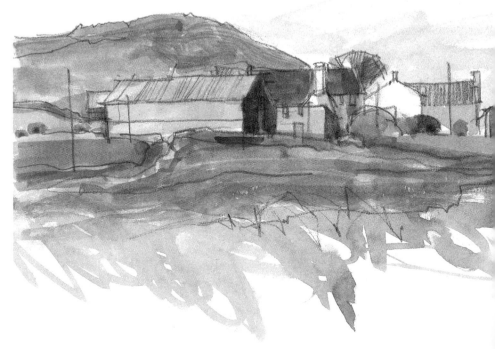

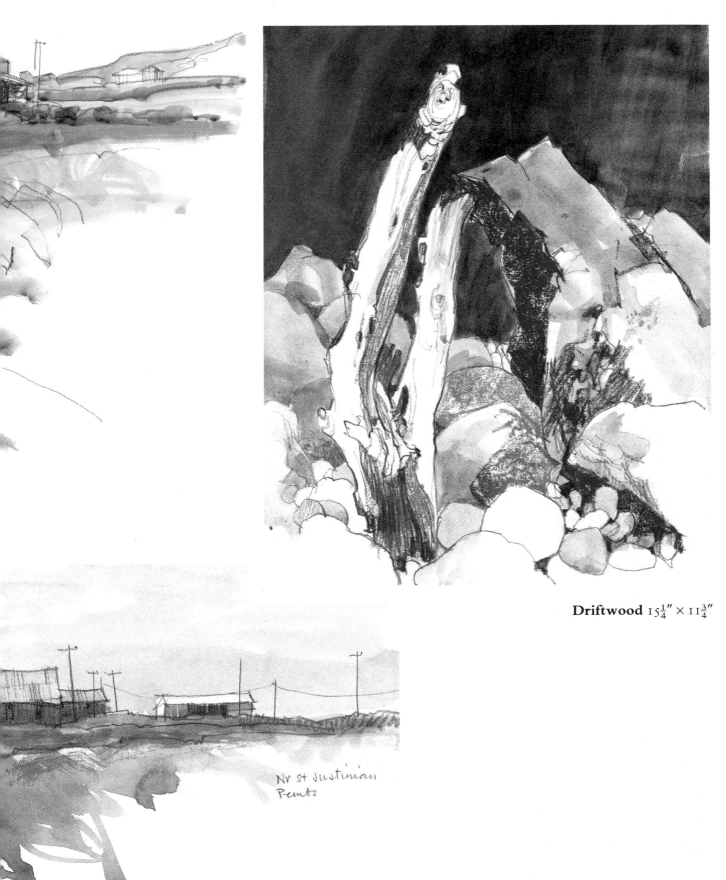

Driftwood $15\frac{1}{4}'' \times 11\frac{3}{4}''$

Nr St Justinian
Pembs

St Justinian

Watercolour, charcoal pencil and pastel

Rhosgadfan, North Wales

This is one of my favourite painting areas, where clusters of solid, sturdy cottages are dotted over the hillside above the coastline, linked by narrow winding roads and crumbling stone walls. Although not a pretty landscape it is full of character and one that I find visually stimulating.

I painted out of doors in order to capture the atmosphere and soft light of late afternoon. Colours were subtle, the greens turning to brown and low in tone. Transparent watercolour on a toned paper helps to set this low key, and I kept the distant washes very subtle so that the land mass and estuary merged with no distinct edges. These first washes of colour were made with a large brush and kept very simple. When they were dry, a charcoal pencil drawing on top enabled me to make a more exact rendering of the subject, before completing the darkest-toned washes.

In *Stage 1* you can see how the drawn line sometimes departed from the position of the preliminary loose washes, as the painting developed. Any additional dark washes were more controlled and confined within the line work.

The more detailed line work on the cottages and walls was made with white, grey and red conté pencils, and

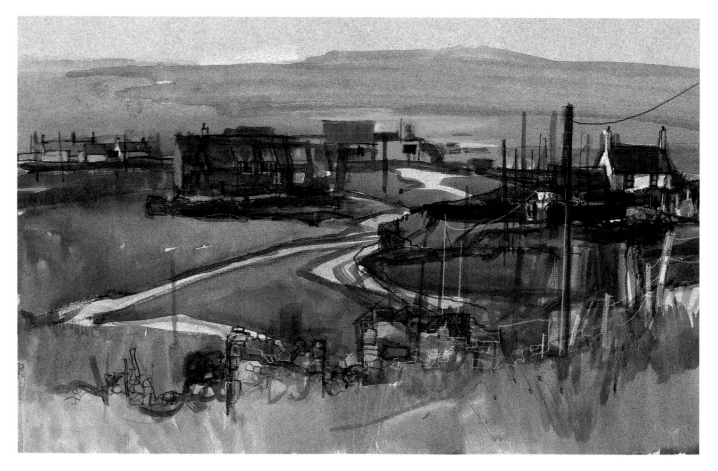

Stage 1

finally I used soft pastel to complete the painting. The introduction of this opaque medium allowed me to paint light tones, and to cover unwanted parts of the first washes.

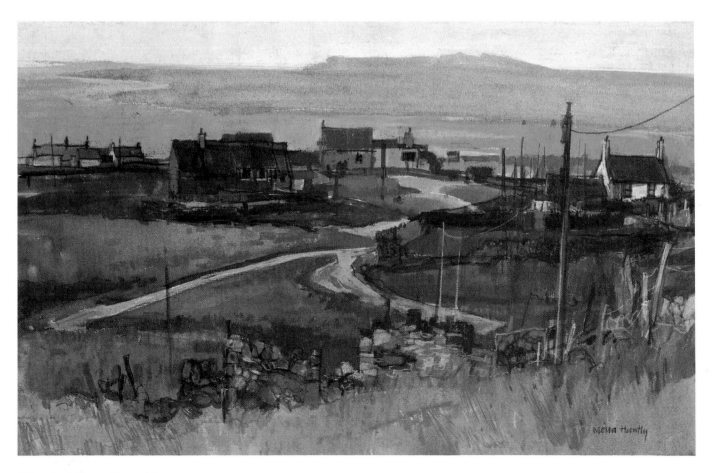

Rhosgadfan 12″ × 19½″

Watercolour and pastel

Cromarty Waterfront, Scotland

This coastal subject was painted in the studio from a sketch that was made on location. Nowadays, most of my work is completed in the studio, where I find the conditions more conducive to making a personal interpretation. As I recall, the actual sketch was made on a bitterly cold winter's day, so I had to work quickly – which is a good discipline.

A few figures braved the elements to 'mess about' with boats, but otherwise this seaside village was enjoying the peace and quiet of the off season. Waterfront cottages were colour-washed in a jumble of pinks, whites, greens and oranges, all soft in the winter light, and the roofs were of slate grey. The written notes on my sketch mention a light tone on the water, but I ignored this in the painting since I thought that a dark sea would make a better tonal pattern alongside the light quay. The jewel-like touches of colour along the row of cottages fascinated me, and I decided that the dark area of water would provide a contrast that would give more emphasis to this aspect of the painting. A change from vertical sketch to horizontal painting also gave emphasis to the cottages by elongating the row, and eliminating the sky.

The painting is on a mid-tone of brown-grey pastel paper, and the main rhythmic shapes of the quayside and figures were drawn with orange and terracotta pastel. In the design of the painting, the dark figure is an important element. Large areas of dark tone divide up the picture area, and these were established with a strong dark olive-brown wash of watercolour. The house on the left has become a dark shape to balance the dark of the water. The watercolour lies matt on the surface of the paper

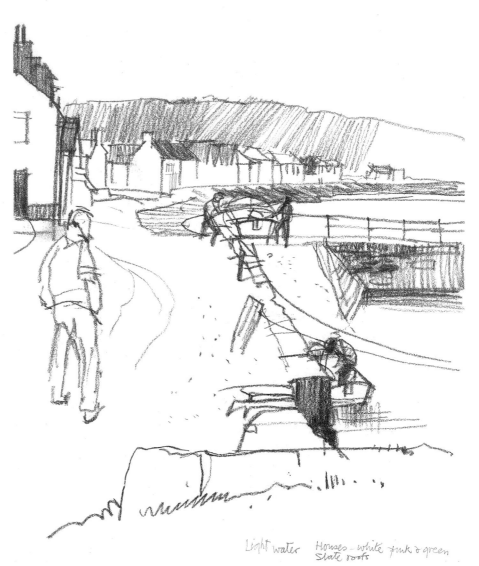

Light water Houses – white pink & green
Slate roofs

and is a calm foil to the vibrant strokes of light pastel elsewhere. Some of the initial line work in the sketch has been adhered to, and in parts it has been exaggerated. Most of the elements in the sketch appear in the painting, although they may have been slightly re-arranged, the only addition being the post on the right. This was added as a link between the two areas of water cut by the jetty.

It is important that the choice of technique should be appropriate to the subject matter, and that it also suits the way we like to paint. No doubt the sketch of Cromarty could have been interpreted in other media, but my choice of pastel and watercolour seemed the right combination at the time. I can't always say exactly why I choose certain media; very often it is an instinctive choice.

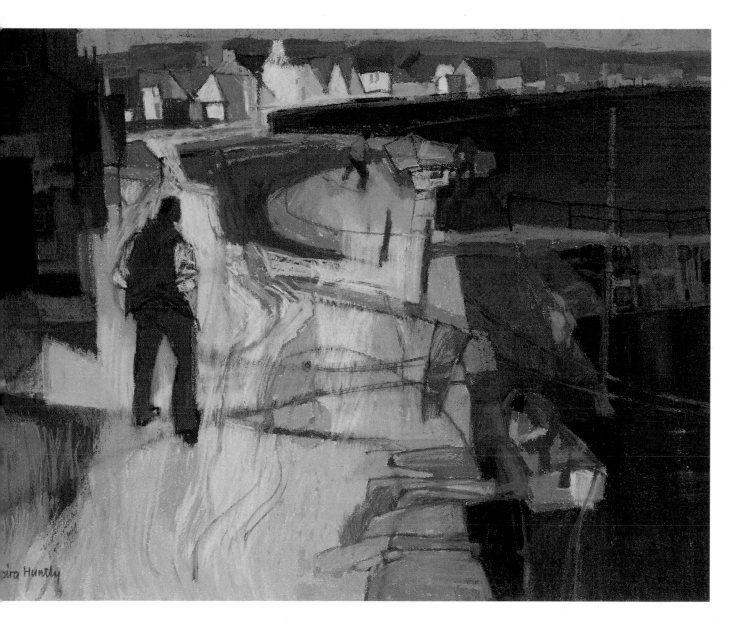

Cromarty Waterfront, Scotland
$14'' \times 18\frac{3}{4}''$

Watercolour and pastel

Drawing of Ram's Skull
(charcoal, charcoal pencil)

Skulls may not appeal to everyone as a subject to choose, but I find the skulls, of horned animals in particular, visually rewarding to draw. Their forms are complex, and I need to observe with some concentration the subtle changes in direction of each curve.

For this drawing I chose a combination of soft willow charcoal and a charcoal pencil and worked on a piece of heavy cartridge paper. First, I covered the paper with a thin layer of willow charcoal, then used the harder charcoal pencil to define the skull. On the top of the skull, I created light tones by lifting off some of the first layer of charcoal with a putty rubber. The bone was weathered and brittle and the mixture of charcoal on rough paper and smoother rubbed areas helped to create the right textural effects. I added more detailed shading with charcoal and finally drew the strongest darks and more precise edges with charcoal pencil, which can be sharpened to a fine point.

Ram's Skull $15\frac{3}{4}'' \times 12\frac{1}{2}''$

In my painting of the underside of the skull the emphasis was on colour and pattern, and I exaggerated the angularity of the subject, particularly within the dark cavities.

A heavy watercolour paper was used as a support and I started with random light washes of raw sienna, cobalt, and olive-green watercolour, allowing the washes to merge. Slightly darker tones of viridian and cobalt blue were painted on parts of the background with vertical brush strokes. I drew the skull with a thin brush line of Hooker's green and when this had dried I reinforced the drawing with a dark tone of Prussian blue pastel. All the darks were established with watercolour, keeping to mixtures of the same harmonising colours already used.

Very light tones of cobalt, pink and creamy-coloured pastel were painted over the bones, the surface of the paper creating a textured effect. Small areas of warm brown and peach colours were introduced to relieve the overall greens and blues. Finally, light pastel was cross-hatched and rubbed across some of the vertical patchwork of watercolour on the background.

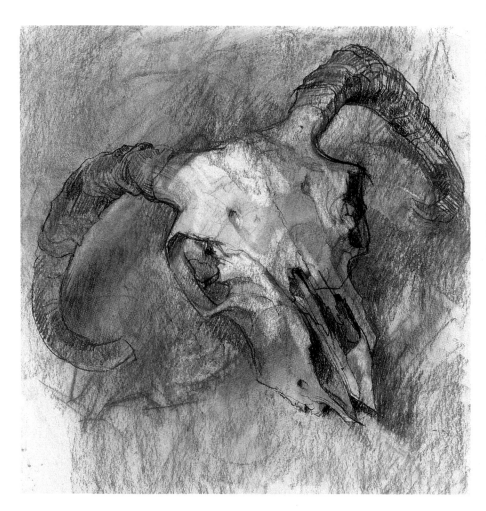

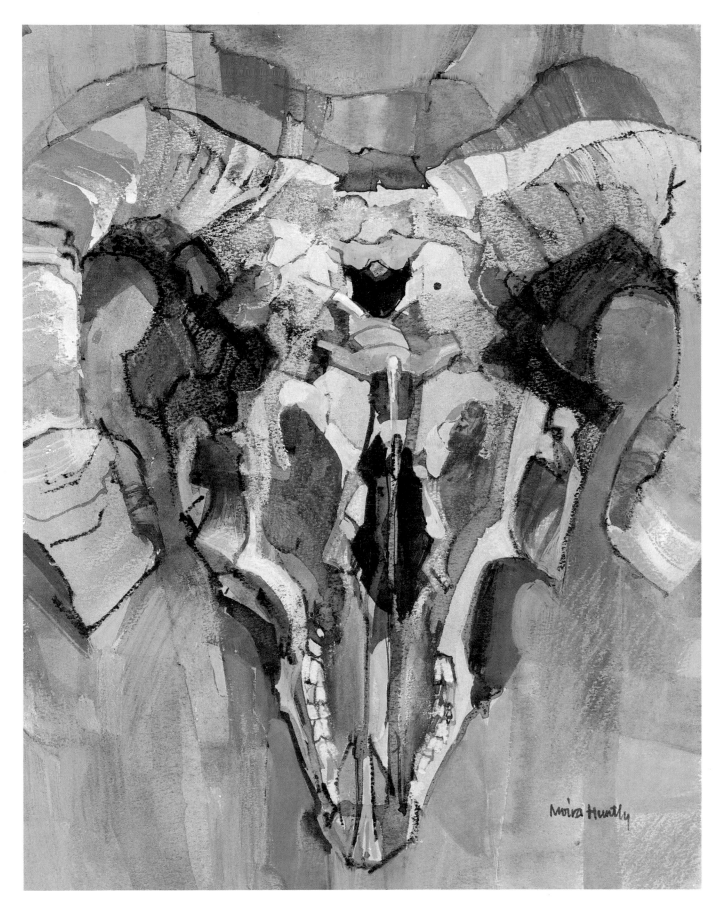

Roller images with printing ink

In this section I am introducing techniques which are related to printing processes, and combining printing ink and turpentine with other media including pastel, acrylic and charcoal. Elaborate equipment is not necessary; all that is required is a sheet of glass or smooth plastic, a tube of black printing ink and a roller (available from art and craft stockists, or possibly a small printing firm).

Printing ink dries fairly quickly, and when a small amount of turpentine is included it will dry with a matt quality which I feel has a particular affinity with the softness of pastel. It can also be combined successfully with most media.

I do a fair amount of printing, having my own small printing press; I also make prints from lino cuts. At the end of each printing session there is the chore of cleaning up the press and the rollers. After pouring some turpentine on the rollers, I roll them out on scrap paper to speed up the removal of the ink. The resulting images are sometimes exciting and so I have decided to utilise these chance effects by occasionally cleaning the rollers on a good quality paper. The type of paper and the effect of turpentine on the roller (which varies the thickness of the ink as it is rolled out) give gradations of tone and texture and sometimes a ripple effect in places. Many such discoveries are made by accident, and much is to be gained by noting and analysing these 'happy accidents'.

Sometimes the cleaning process produces roller images that are interesting in themselves in an abstract way, and sometimes the images will suggest various subjects. Very often a different subject may suggest itself if I turn the paper around. Visual impressions can often provide the starting point for a painting where the subject has not previously been decided. I think that this is a valid way of working; textures or random effects suggesting the subject rather than the other way round. This does not mean that the artist is not in command for decisions still have to be made, ideas developed and the composition organised.

In the roller images shown here I can read various subjects, but I leave you to look and make up your own mind as to what subjects they suggest to you.

These roller marks, once they are dry, can be used as an underpainting and can be successfully combined with most media – including soft pastel, oil pastel, oil paint, acrylic paint, gouache and watercolour. They can also be drawn into with conté pencils to refine or make the suggested images more specific.

Figs. 1 and 2 Printing ink and turpentine on heavy cartridge paper.

Fig. 3 Printing ink with plenty of turpentine on smooth card,

Fig. 4 The same as *Fig. 3* but ink is drying off.

Fig. 5 Printing ink with watercolour washes.

Fig. 6 Printing ink with pastel pencils.

Fig. 7 Printing ink and turpentine.

Fig. 1

Fig. 2

Fig. 3

Fig. 4

Fig. 5

Fig. 6

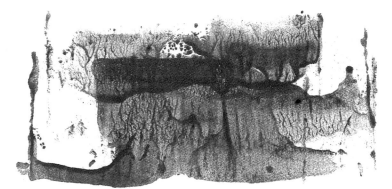

Fig. 7

Roller images
with acrylic

Stage 1

Stage 2

Stage 1 At first, this roller image suggested still life objects, then I suddenly saw a bird and tree trunks.

Stage 2 Gradually the painting evolved in my mind and I started to add touches of colour with thin glazes of acrylic paint. With the addition of dark tail feathers a second bird took shape on the left, and a few leaf forms added further credence to the idea of trees and branches.

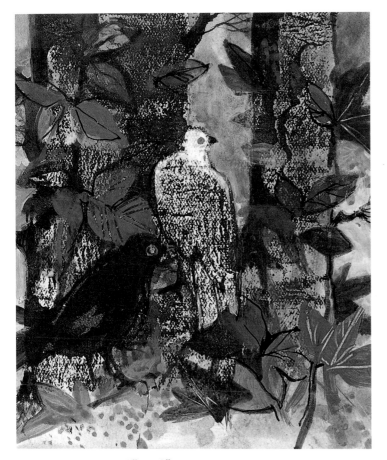

Trees and Birds $4\frac{1}{2}'' \times 3\frac{1}{2}''$

Stage 3 The finished painting allows some of the original ground to show through the acrylic glazes, and on other parts of the original ground the colour has been adjusted with the covering power of thick acrylic paint. Fine lines are added with thin black acrylic paint on a no. 0 sable brush. After using acrylic paint it is important that all brushes are rinsed out immediately.

These little paintings are fun to do and exert the imagination.

Roller images with acrylic

For these images, I made use of the printing process again, but this time I utilised the ink left on the inking plate before commencing the task of cleaning up after my printing session. My small press has a circular inking plate which accounts for the unusual format of the printed image as a broken circle.

I placed a small rectangular piece of thin cartridge paper over the ink and drew this bird design onto the back of the paper with a hard pencil, so that an impression would be made through the thickness of the paper onto the ink. (*Fig. 1* shows the pencil doodle on the back of the paper.) Then the paper was lifted off the ink plate and *Fig. 2* shows that the pressure of the pencil resulted in a rather blurred dark line of ink.

A reversal of this effect (in *Fig. 3*) was obtained by placing a second sheet of paper onto the undisturbed surface of the inked plate and rubbing the back of the paper. The doodle which had been previously incised into the ink surface now appears as a white line, making a negative image. Had I wished, I could have re-inked the plate and repeated the whole process.

In the painting shown opposite, I had chosen the image in *Fig. 2* to develop further with added colour. For this I used acrylic paint thinned with acrylic gel medium to produce translucent glazes of colour. The off-set print image can be seen clearly through the layers of transparent colour.

Fig. 1

Fig. 2

Fig. 3

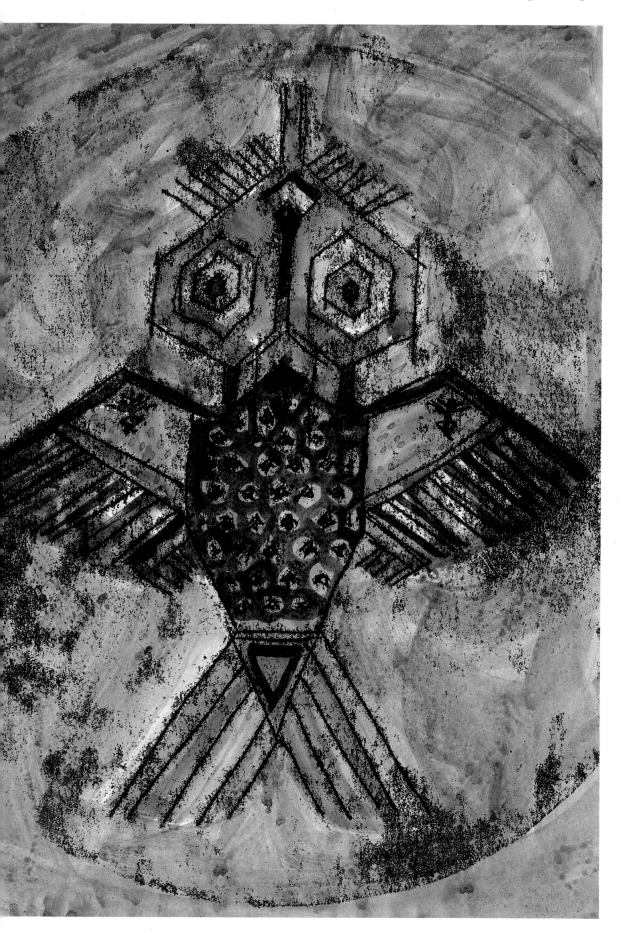

Stylised Bird
$10\frac{3}{4}'' \times 7\frac{1}{2}''$

Printing ink, turpentine, conté pencil, charcoal and pastel

The Plane $12\frac{1}{2}'' \times 8\frac{1}{2}''$

My discovery of the use of the printing press rollers introduced me to the idea of using the printed images as a base on which to work. Sophisticated printing equipment, however, is not essential. I frequently use a small hand roller to pick up printing ink squeezed onto a piece of glass or smooth plastic. By the simple operation of rolling the ink onto my paper I obtain the inked impressions I require.

I prepared such roller marks on heavy cartridge paper for the underpainting of 'The Plane'. They vary: some being heavily inked, some unevenly inked, some nearly dry, with other effects achieved by varying the amount of turpentine used. I squeezed a small amount of black printing ink onto a sheet of glass and a few drops of turpentine onto another part of the glass. After making some roller marks with the ink alone, I rolled the roller into the turpentine and then made more marks. Occasionally I added a few drops of turpentine directly to the roller to increase some of the wash effects. The heavy, rather coarse, cartridge paper that I was using quickly absorbed the wet turpentine and ink mixture from the roller.

In this painting I tried to create a visual excitement out of static workday objects by looking for patterns within the shapes, and emphasising surface textures by the use of mixed media. Mechanical subjects have great potential for providing the artist with abstract shapes and rhythms which, when combined with painting in a mixture of mediums, create an unusual visual impact. As a foil to the rather sombre metallic colour choice which befitted the metal objects, I added a few touches of warm-coloured pastel on the plane.

The first medium that I used in the initial stages of the painting was black printing ink thinned with turpentine substitute, and this was applied with a printing roller onto heavy white cartridge paper. A study of the marks resulting from the random application of the roller helped to suggest the positioning of the subject matter.

When the ink was dry, outlines were defined more positively with a charcoal pencil and the construction of the painting progressed, based very much on a pattern of rectangular and rounded shapes. The plane itself is basically a vertical rectangular shape, and is echoed by other such shapes. The bottom right corner contains vertical rectangles, and a grey pastelled shape superimposed over a larger blue-grey shape. Essential in the painting are several smaller rectangular shapes, but these are deliberately made less obvious in order to prevent monotony. The plane itself contains some curved lines and these are echoed in the spanners.

The combination of printing ink and dragged charcoal over white paper gives a sparkle and metallic sheen to the surface of the plane, and this is emphasised by the relatively flat areas of pastel and darker tone elsewhere.

Watercolour and gouache

Watercolour and gouache are both water-based mediums. The former is transparent, whereas gouache (sometimes referred to as body colour) contains the white pigment which makes it opaque. The effect of working with these two mediums is similar in some ways to the combination of watercolour and pastel, but unlike pastel, gouache can be worked wet into wet and flare into a watercolour wash, or it can be diluted to give a transparent filmy wash. It can also be mixed directly with watercolour.

Transparent colour is most effective when used on a white ground which will reflect the light through the pigment, and gouache is most effective on a toned ground which can make the covering power of opaque paint more obvious. Combining the two mediums in the same painting enables a wider choice of painting surfaces to be used successfully, so supports can include cartridge paper, watercolour paper, pastel paper, Ingres board or cardboard.

Techniques

1. Cream-coloured gouache is brushed across a watercolour wash before the wash has dried, causing the gouache to soften and flare into the watercolour.

2. A dark wash of watercolour is left to dry. Thick gouache paint is dragged across, giving a broken, dry-brush effect.

3. Dilute gouache is painted over dry watercolour washes, giving a soft filmy effect.

4. Patches of thick cream-coloured gouache are applied first and left to dry. Dark watercolour is quickly washed over the surface with a well loaded large brush. It adheres to the surface of the gouache, giving a mottled effect. In the central patch of 'Still Life with Fruit and Orange Teapot' I scraped most of the watercolour away from the gouache and then scratched textures in the exposed gouache with a knife.

Fig. 1

Fig. 2

Fig. 3

Fig. 4

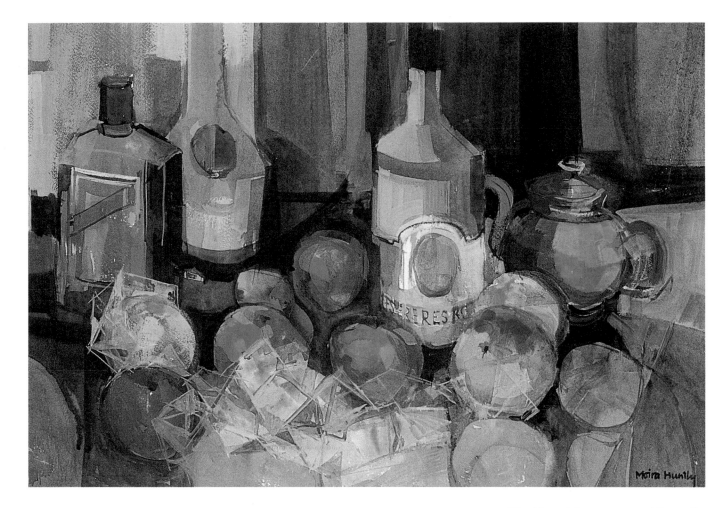

Still Life with Teapot $14\frac{1}{2}'' \times 22''$

Still Life with Fruit and Orange Teapot

Mixed water-based media have been used in the still life painting above and many of the techniques shown here have been employed. The support was 140 lb (295 gsm) Saunders NOT watercolour paper.

I often start a painting in abstract terms, placing big shapes, tones and movement and gradually develop the literal part of the painting. In this case I distributed the pattern of colour first, using brilliant transparent washes of vermilion, cadmium orange, Winsor emerald and Hooker's light green.

These bright patches of colour were flooded onto the paper without attempting any precise definition at this stage. Darker tones were painted with mixtures of vermilion and Hooker's green or vermilion and Prussian blue, increasing the depth to a very dark rich blue-green. Some definition was now introduced with a thin brush and green or brown watercolour. The line work can flow across the surface very freely at this stage, and be adjusted later if required, when opaque gouache paint is introduced.

Gouache has been used with a minimum of water on parts of the background, giving a dry-brush effect which allows the underlying wash of transparent watercolour to show through. Light on the teapot and fruit has been painted with thick slabs of gouache, and the bottles have been painted with smoother thick gouache. Finally, more water is added to the gouache paint and a filmy layer is painted over the crumpled paper in the foreground, giving a translucent, almost transparent efect.

This freedom to develop and experiment with a painting is part of the joy of mixed media.

Watercolour and gouache

Poole Harbour, Dorset

My eye was attracted by the pattern of the rock shapes in the foreground and the path zig-zagging its way towards the boats and figures. The flat slabs of light stone on the path lead nicely up into the compositon and their strongly geometric pattern is echoed by the boat shapes. I thought of the boats as a group that made a pattern of light and dark shapes, some individually silhouetted against the sky.

Stage 1 This is a wash of raw sienna watercolour all over the paper, with pale washes of French ultramarine blue to indicate some of the darker tones that I saw in the subject.

Stage 2 With a fine brush and ultramarine watercolour I outlined the boats and buildings and indicated the pattern and shapes of the rocks. I added a little olive green to parts of the rocks and a little burnt umber onto the boats.

Stage 3 After completing most of the dark tones with watercolour, I introduced opaque gouache and started with the sky, painting carefully around the profile of the boats and buildings. Then I massed in the rest of the sky, using a large flat brush, a mixture of white and a little ultramarine blue gouache, and working from the profiles with upward strokes. The warm underpainting glows through in places. Then I developed the boats and foreground, strengthening the dark tones with ultramarine blue mixed with burnt umber gouache paint. The lighter areas were mixtures of Naples yellow and burnt sienna, modified by adding some white in places.

Stage 1

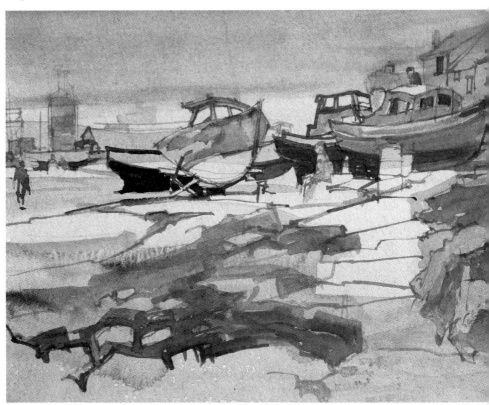

Stage 2

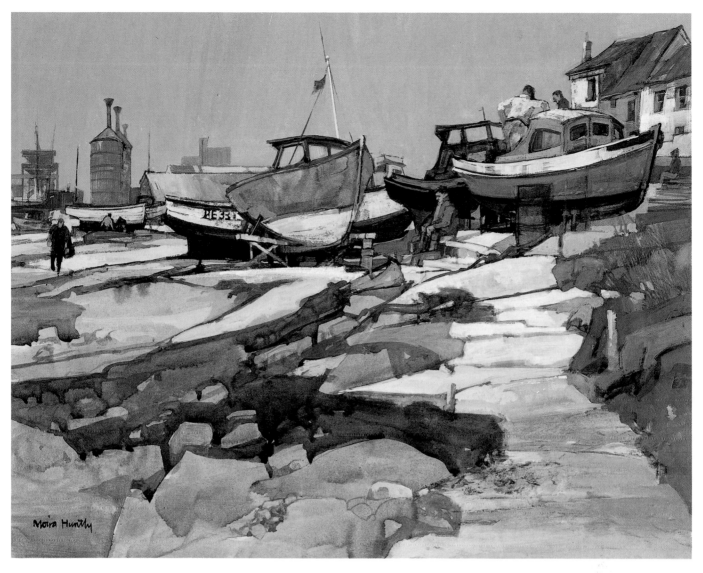

Poole Harbour 12″ × 16″

Very few colours are used in this painting, which gives a unity without being a monochrome. I tried to place the emphasis on low key colour, high-lighted by the slabs of light on the pathway. The sky is deliberately a flat area of colour as a foil to the patterned ground.

Watercolour, gouache and pastel pencil

Portrait of Shena

This portrait followed the same general process as the previous 'Still Life with Fruit and Teapot' painting. It was painted on 140 lb (295 gsm) Saunders NOT watercolour paper, and I began it with transparent washes of cadmium orange and permanent magenta watercolour, freely applied, and without any attempt at definition. While the washes were still wet, I tilted the paper in various directions to create runs of paint across and down the paper, and as these first washes began to dry I made further paints run through them. These paint runs can be controlled to a certain extent, but much of the result of these paint runs through wet and partly dry washes is random, and creates a decorative background.

When the background was dry, I lightly outlined the figure, using a dark red pastel pencil, then I began to develop the painting of the figure with opaque gouache, using white with touches of orange or Tyrien rose and umber for the skin. Suggestions of folds and deep pink shadows in the sleeves and skirt were painted with broad brush strokes of Tyrien rose mixed with white. I added a small amount of lamp black gouache to make a subtle dark tone for the background in order to define the head. The dark bodice and hair were painted with more dilute mixtures of cadmium orange and lamp black gouache which allowed some of the original magenta wash to show through in places. Further decorative treatment was added to the skirt and areas of background by scumbling cadmium orange gouache over the first washes. 'Scumbling' is the dragging of a thick opaque layer of paint over a different layer of thin paint in a broken, uneven way which allows some of the underpaint to show through. Although the treatment appears haphazard, almost careless, the process was, in fact, very definitely organised. The first transparent colour washes were chosen to give a brilliant background, with white paper reflecting them to create the luminosity associated with pure watercolour. Then in subtle contrast, the opaque gouache creates a matt dull sheen to the face and parts of the dress. There are also definite elements of design within the composition, the pink content of the sleeve being repeated in the vertical shape in the top left of the painting, which in turn is echoed by the horizontal rectangle behind the figure.

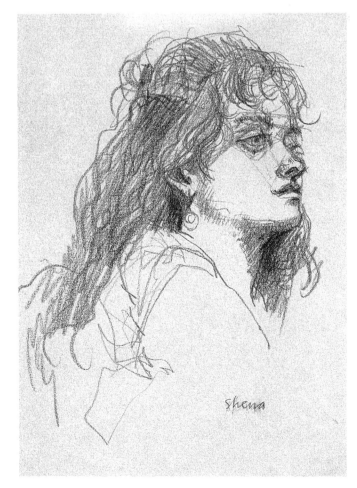

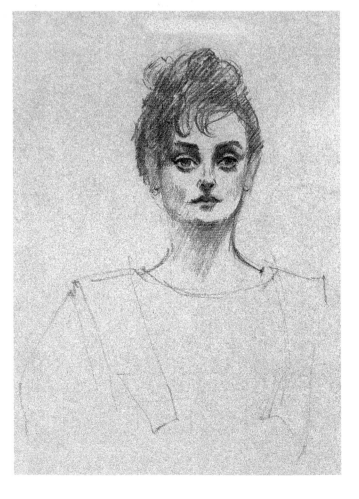

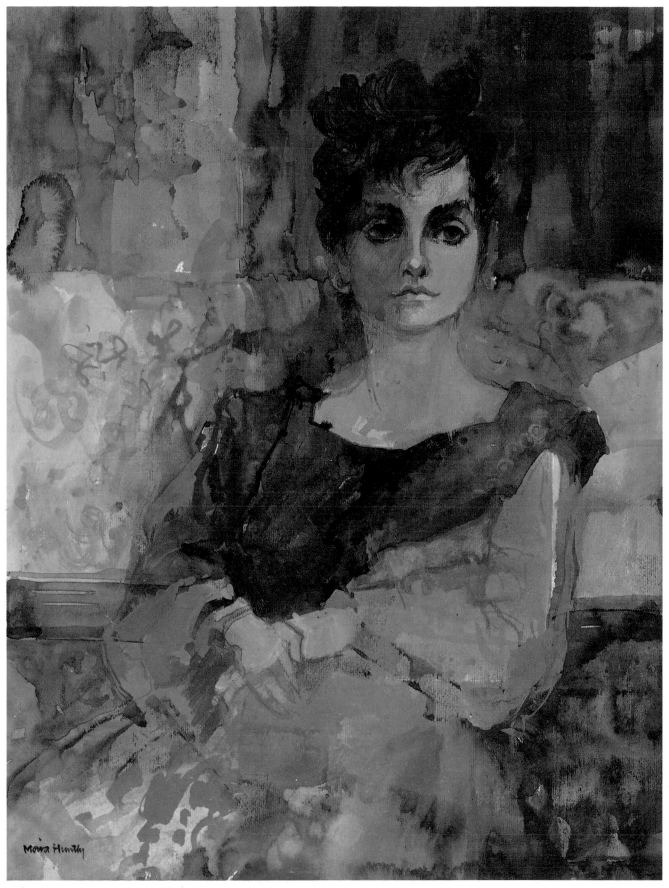

Portrait of Shena 19″ × 14″

Drawing of Ian
(charcoal pencil)

This sketch was made with a black charcoal pencil and the painting was created in the studio much later, entirely from the information which the sketch provided. It was not my intention to concentrate on creating a likeness, my main interest being to experiment with the mixed media. However, as it turned out, my sitter was well satisfied with the result. In the process of translating the sketch into a painting a few adjustments were made to the arrangement. The figure occupies a central position with more space above the head, and the vertical window bar has been brought further into the painting.

Watercolour, gouache and pastel pencil

Portrait of Ian

I started with background washes of cadmium yellow and dilute magenta watercolour, and paint runs were induced (as in the previous painting) through wet and drying paint. Some of the runs terminate with beads of paint that have dried as dark blots.

With the background established, the figure was defined with dark grey and dark red pastel pencils and washes of dilute gouache. The material on the settee was suggested with vertical bands of filmy gouache and darker bands of harmonising colours. Dark tones were added to the top half of the background by an off-set process, which involved painting a piece of smooth card with dilute gouache and, while it was wet, pressing the card paint side down onto the painting. A second pressing as the paint was drying on the card gave a more textured result. Light tones on the figure and the cap were built up with thicker gouache, and finally the window bars were superimposed with watercolour and touches of gouache.

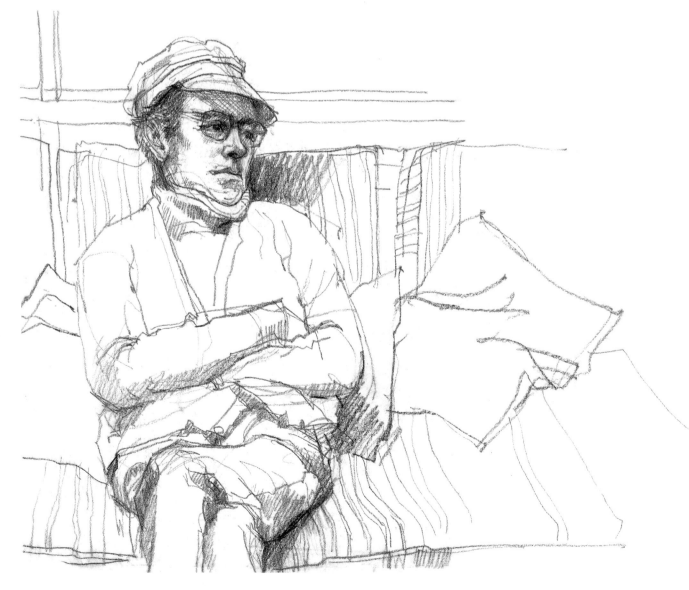

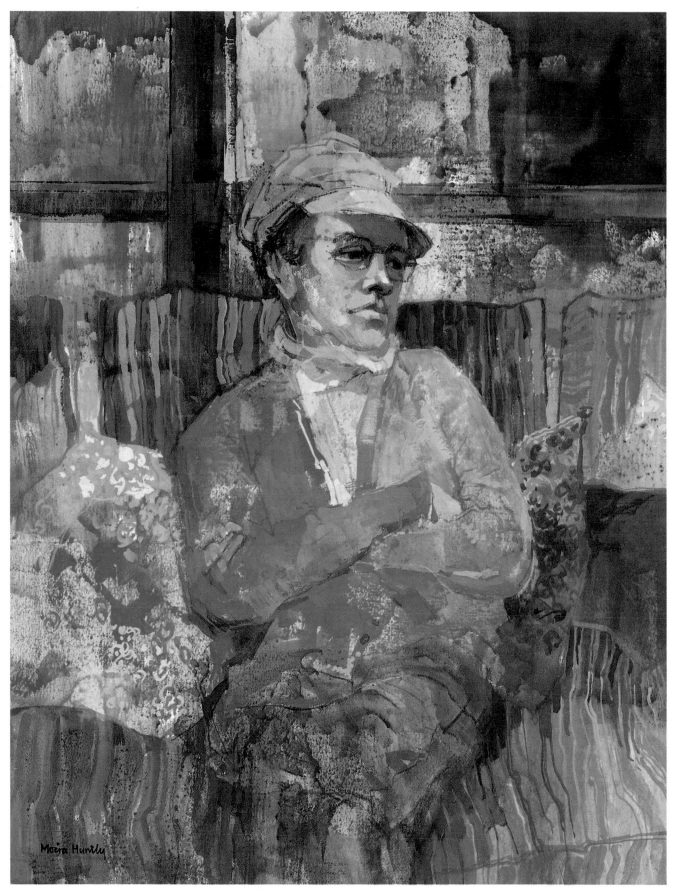

Portrait of Ian $19\frac{1}{2}'' \times 14\frac{3}{4}''$

Drawing of Abertillery, South Wales
(conté pencil, pens)

It was pouring with rain and I had to work in a parked car to make this sketch of a mining town in South Wales. Despite the rain, the town was visually exciting, with its narrow streets on different levels, and its closely-knit houses, each distinctively painted, clustered together up the steeply sloping sides of the valley.

The initial drawing was made with dark grey conté pencil, to position the main groups of buildings and establish the perspective. I also scribbled some shading over the dark hillside behind the houses, which helped to emphasise the impression of light on the buildings. Finer details such as brickwork, windows, chimneys and railings, were recorded more effectively with a fine drawing pen. For this I used an Edding Profipen, and then indicated large areas of dark with a broader black fibre-tipped pen. Colour notes were added with Stabilo felt tips, which can be purchased in a wide variety of colours.

The drawing was pinned up in the studio for some time before a painting was started. This is a deliberate policy, for I like to have work in progress on view, to allow time for ideas to evolve.

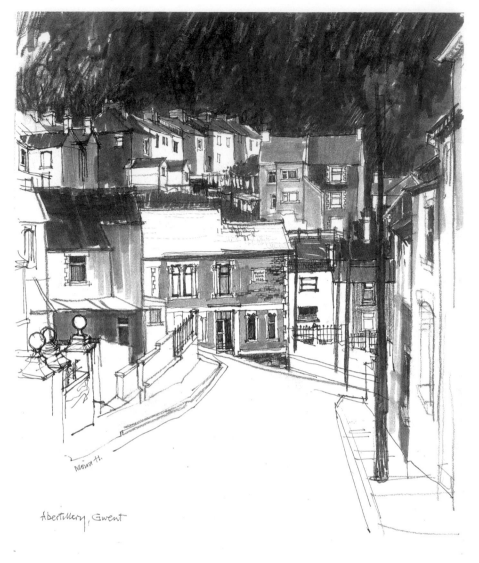

Abertillery, Gwent

Watercolour, gouache and pastel pencil

Abertillery, South Wales

The choice of mixed media for the sketch inspired me to use mixed media in the painting. The format, however, was changed from a vertical sketch to a painting of wider proportions, which gives a feeling of having 'zoomed in' on the houses. My interest lay in a pattern of geometric shapes seen within the group of

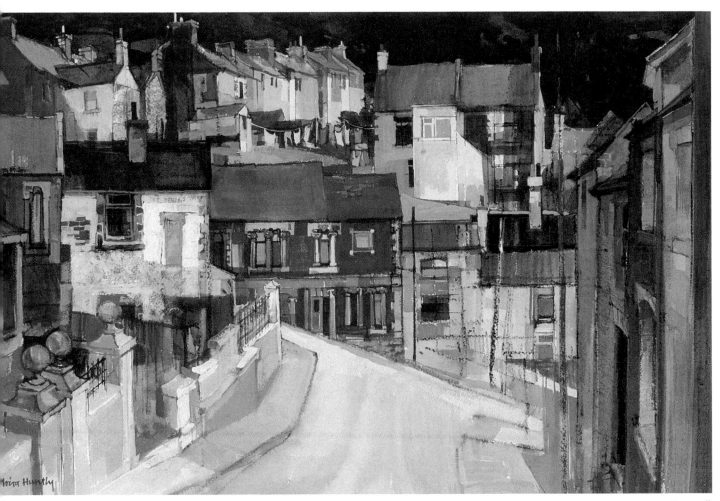

Abertillery, Wales $14\frac{1}{2}'' \times 22''$

buildings, squares and rectangles of differing dimensions and repeated shapes. The slope and light tone of the road is echoed in the tone and slant of the end wall of the cream building to the right of centre. It is these abstract factors which interest me most at the beginning of a painting.

The painting, which was on 200 lb Bockingford watercolour paper, was started by my blocking in the big shapes and rhythms with broad washes of Prussian blue watercolour which dried fairly light in tone. Darker-toned shapes were gradually developed with Prussian blue deepened with burnt umber. These first washes of transparent colour were allowed to dry, and then the subject

was defined more clearly by drawing with blue and sanguine pastel pencils. Further strong darks were started with a mixture of burnt umber and Payne's grey watercolour.

At this stage the painting had a strong drawing on top of the first broad washes. These washes had dried with a variety of edge values from hard to soft; in some areas the colour had run and in other areas the wash had dried, leaving a mottled texture. These effects were quite randomly distributed over the buildings, which meant that the washes were not necessarily all desirable or in the right place. This was not a worry because I had planned on using gouache and knew that it has the covering power to

eliminate any unwanted parts of the first wash.

The introduction of opaque paint enabled me to develop areas of solid colour, strong light and textures within the painting. This process was one of continual choice as to which areas of original wash to leave untouched as part of the final painting, and on which areas to concentrate the light with a layer of gouache paint

The combination of transparent thinly-painted areas, creamy opaque paint dry-brushed in places, and broken line work, all helped to create an impression of crumbling plaster and rain-washed houses perched against the rather ominous dark side of the valley.

Watercolour, white gouache and conté pencil on toned paper

Farm near St David's, Wales

This is an exercise in using toned paper, conté pencil, and transparent watercolour washes, augmented by opaque paint to increase the tonal range. I like to use a good quality pastel paper because it will not fade. This 'on the spot' sketch of a farm in South Wales was made on pearl-grey paper with a soft dark-grey conté pencil.

I recall that it was a bright sunny day and that I chose a tinted paper in order to cut down the dazzling glare that can be produced by white paper. I drew the subject with a loose, free line and did not do any shading with the pencil, having decided to record the light and shade with washes of watercolour which at the same time would provide me with a record of the colour.

A dilute wash of Payne's grey over the sky cooled the warm pearl-grey colour of the paper without any significant lowering of the tone. A less dilute wash of the same colour was brushed over the distant hill, the trees, and the shadows on the building. As I worked, the paint sank into the paper and dried instantly with the heat from the sun, so warm colours were immediately added over the buildings, hedge and central field with varying tones of burnt umber and burnt sienna watercolour. The colour of the paper transmits through these transparent colour washes and creates a unity because, in effect, it mixes optically with each colour.

Olive green and Hooker's green were added to my palette and very dilute washes of umber and olive were used on the foreground, and a stronger mixture of umber with alternately Hooker's green or olive green on the rather wind-blown tree on the right. Although the colour range is very limited, variety can be achieved by changing the colour combinations.

At this stage the tonal range in the sketch was also of a limited scale, the lightest being the grey tone of the paper through to the darkest area of watercolour. To extend this tonal range and capture the extra light areas in the scene I made use of the opaque quality of white gouache paint. It can be mixed successfully with transparent watercolour, and I added lemon yellow watercolour to it for the distant field, and a more dilute mixture of white gouache for the foreground stones and parts of the building. This process allowed me to emphasise some of the variation of tone that I had observed. For instance, the tree on the right has two trunks, one is light against the dark brown field and the other is mostly darker than the field. I also noticed that the buildings on the left have roofs which are dark against the tone of the sky, while those in the right hand group have roofs and chimneys that catch the light and appear lighter in tone than the hill behind.

I find mixed media to be particularly useful in enabling me to complete the recording of tone in conjunction with colour in a working drawing. It would be interesting to repeat the process on, for example, a piece of pink pastel paper, thus allowing a totally different colour emphasis to permeate the painting.

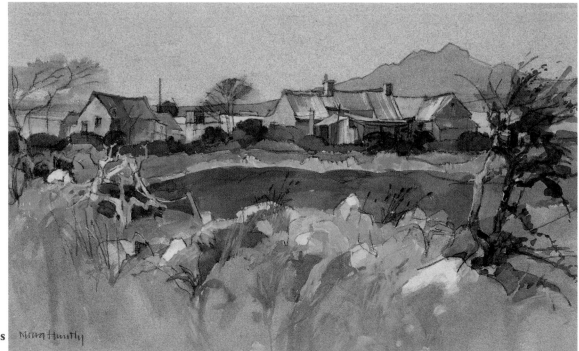

**Farm near
St David's, Wales** Mora Huntly
$11\frac{1}{2}'' \times 19\frac{3}{4}''$

Watercolour, gouache and conté pencil on toned paper

Llithfaen, Wales

I managed to do most of this painting whilst perched precariously on the top of the wall, halfway up this narrow road in North Wales. The combination of dark chimney pots and telegraph poles against a matt sky took my eye and inspired me sufficiently to feel that the subject was worth all the discomfort of the only vantage point. For difficult sketching situations such as this I have a foam rubber cushion in a polythene carrier bag. The cushion eases the discomfort of sitting on a hard stone for a long time, and the polythene bag keeps my feet dry if the grass is wet. A broken fence post became my 'easel' and I wedged my water pot between the stones, hoping that no essential piece of painting equipment had been left in the car at the bottom of the hill. Happily, all was

well and the drawing flowed rapidly, using a dark-grey conté pencil on a piece of mid-grey toned pastel paper.

The houses were at the top of the rise and to emphasise this I decided to place them towards the top of the paper, and to allow the telegraph poles to lead up and out of the top of the painting. But my first decision related to the placing of the middle pole. I liked the idea of it being placed off-centre and by drawing it in a position to the right of centre there was enough room on the paper to be able to draw the complete row of houses seen on the left. This was the main attraction of the scene, with chimneys all higgledy-piggledy, varying in height and differing in spatial relationships, a black-fronted dwelling against the stark whitewash of its neighbour, and then the muted green of the next house. To my delight a black crow perched briefly on a chimney pot, its silhouette sharp against the sky.

I added washes of watercolour to the conté drawing and a touch of gouache to the lightest houses as a reminder of the colour and tone.

Back in the studio some weeks later I completed painting the light areas with gouache. First, the sky, which had originally been left as grey paper,

was covered with opaque pale grey-green gouache. The effect on the painting was quite dramatic; it emphasised the chimneys and the pattern of sky shapes between the telegraph poles. Lightening the sky area also emphasised the closeness in tone of the rest of the colours in the painting. The colour of the paper also played an important part in this tonal harmony, for transparent watercolour on a tinted paper has a tonal unity which, in this painting, is set off by the covering power of gouache to create a light-toned area of contrast. However, the contrast between sky and roof line had not been the entire concept of the painting – I had also been interested in the stronger contrast of the dark windows against the white-washed house front, which added more punch to the painting and provided an area of sharper definition as a focal point. The road, in fact, leads the viewer up to this area.

The initial conté pencil drawing was strengthened on a few of the dark chimneys and windows by adding a strong wash of transparent watercolour. Alongside the light-toned areas of gouache this increased the interest by creating a contrast of medium as well as tone.

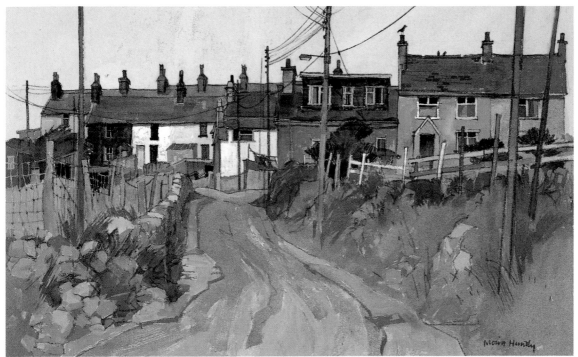

Llithfaen, Wales
$12\frac{1}{4}'' \times 19\frac{1}{4}''$

59

Watercolour monoprint and gouache

This is one of the simplest of printing processes which I have used in several sections of this book, using various media. Basically, the principle of a monoprint is that an image is made with paint or ink on a smooth surface such as glass or plastic. A piece of paper is pressed onto the glass before the paint or ink has dried and then carefully lifted off. The resulting image which has now been transferred onto the paper is, of course, a reversal of the original painting.

When making a monoprint with the watercolour medium I add a small amount of liquid detergent to the paint mixture. This prevents the paint from drying up too quickly on the glass and gives time to draw into the paint with the end of a brush, and to make alterations by wiping out areas. The detergent can also suspend the paint in little globules on the glass, which off-print onto the paper as blots and spots.

Fig. 1 This shows some flower shapes produced by the monoprint process. Here I mixed yellow transparent watercolour with a little water and a small amount of liquid detergent and brushed it onto the glass roughly in the shape of flower heads. I used 90lb

Fig. 1

watercolour paper and dampened the back of it slightly with a sponge and a small amount of clean water. This softened the paper and made it easier for it to pick up paint when pressed onto the glass. Some of the mottled effects seen here were produced by a combination of wet sticky paint on glass and variations in pressure of rubbing which created interesting modulations in the paint surface.

Fig. 2 This is a variation of the process. I used a large brush and painted watercolour, only slightly diluted, over the face of an actual leaf. I placed the leaf on a piece of paper, painted side down, and covered the leaf with another piece of paper which I rubbed to transfer the paint and produce the leaf image shown here. When dry these images can be developed further by drawing or by adding colour washes. Gouache, ink or oil paint can also be used as a medium for leaf prints.

Fig. 2

Flowers in a Jug

My painting of a jugful of flowers was started by the monoprint process and developed by painting and leaf printing with both gouache and watercolour.

Stage 1 The orange-yellow and purple flowers, stems and jug were painted onto a sheet of glass and transferred to a piece of watercolour paper. When this was dry I painted the blue grey background wash directly onto the paper.

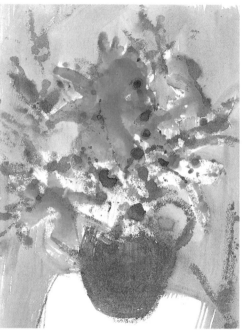

Stage 1

Stage 2 Here I added leaf prints directly onto the painting, using a variety of leaves, often repeating a particular leaf, and sometimes overlapping and printing with opaque gouache. Definition was given to a few of the leaves by adding a wash of watercolour once the print had dried, and some extra flower shapes were added with gouache.

The table was painted with gouache in bright fresh colour, echoing some of the colour in the mass of flowers. These additions of gouache create solid patches of paint which make an interesting contrast to the mottled printed surfaces.

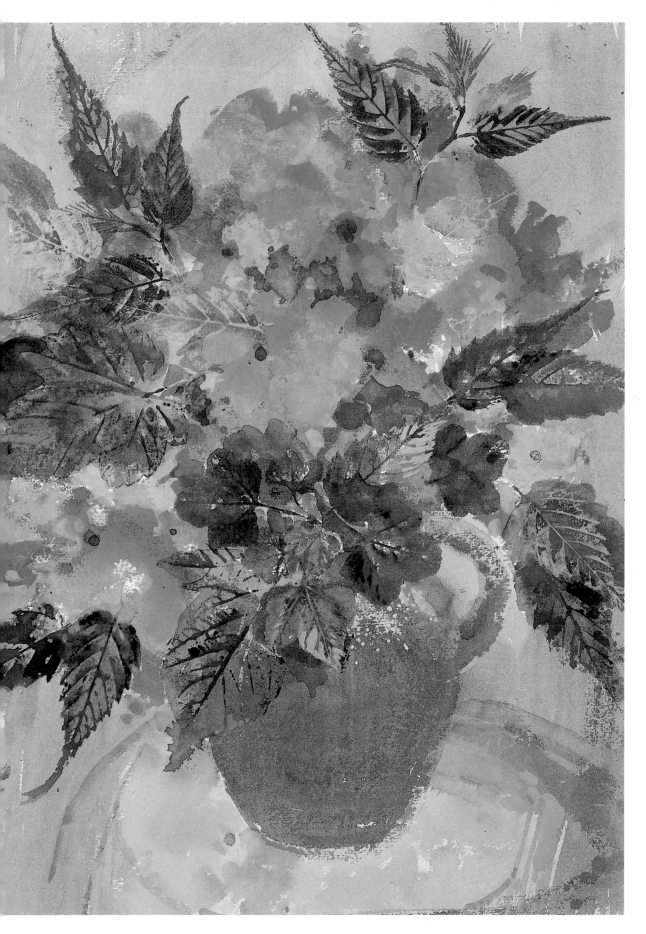

**Flowers
in a Jug**
$15'' \times 10\frac{1}{2}''$

Roller images with watercolour and gouache

The next group of paintings in this section all incorporated an underpainting where the paint was distributed in an uneven and sometimes subtle manner. To this end I introduced another painting tool in the form of a roller, using it as already described on p. 40. Effects vary, depending upon the type of paper used and the degree of water in the mixture of paint, but the images that result are intriguing and can often stir the imagination.

Roller marks

Fig. 1 This shows the result of using transparent watercolour on smooth hot pressed paper. The paint flows freely and covers the paper, gathering at the edge as the roller is lifted off.

Fig. 2 Dilute gouache on hot pressed paper. This paint was of slightly thicker consistency than *Fig. 1.* and was deposited by the roller in an uneven manner.

Fig. 3 Dilute gouache on 140lb Saunders NOT watercolour paper. The rougher surface of this paper causes a broken, more textured effect.

Fig. 4 Gouache on 200lb Bockingford watercolour paper. Drier paint and an uneven coating on the roller gives solid deposits and a spotty texture.

Fig. 1

Fig. 2

Fig. 3

Fig. 4

Fig. 5

Fig. 6

Fig. 7

Fig. 8

Fig. 5 Watercolour on toned Ingres paper. The ridged tooth on the support is pronounced.

Fig. 6 Identical Ingres paper with the surface dampened with clean water. More subtle effect, and the texture less obvious.

Fig. 7 Very dilute white gouache on dark mountboard. Dries with blotchy edges as the paint flows to the edge when the roller is lifted off.

Fig. 8 Thicker gouache on dark mountboard with the addition of very thick gouache (straight from the tube) deposited with the end of a cork.

Fig. 1

Fig. 2

Watercolour, gouache, conté pencil, pastel pencil and pastel

Village in the Yorkshire Dales

This painting was made in the studio from a pencil sketch of a Yorkshire village, viewed from high ground and looking down onto the huddle of limestone buildings. I remembered the soft colouring of grey greens and the light reflecting from the pale-grey limestone walls.

I chose deep green Fabriano Ingres paper, and much of the self-colour of this paper was left untouched by colour and became incorporated into the painting, especially on the shaded sides of the buildings. The painting began with random patches of dilute Naples yellow gouache applied with the roller. The texture of the paper caused the paint to be deposited unevenly and it dried with a mottled effect, which resembled small rounded trees. I made use of this effect in places by filling in some of these 'tree' shapes with olive green gouache, and some were left as dark green paper. These patches of paint, together with the colour of the paper, combined to give an impression of the landscape. Elsewhere in the painting I use soft pastel to develop the random shapes into buildings.

I used mid- and light tones of olive green pastel, light grey pastel, very pale burnt umber, blue grey and a mid-tone of warm grey. Main outlines, gates and windows were drawn with a conté pencil, and coloured pastel pencils were used to add touches of warm colour on the chimneys. The pastel in these pencils is a little harder than the normal sticks of soft pastel, and are useful for adding more precise details to a painting.

Roller images

Fig. 1 Mauve watercolour rolled over 140lb Saunders HP paper. The process is repeated with dabs of Tyrien rose gouache added to part of the roller. The surface varies from complete coverage to very slightly mottled, depending upon the dilution of paint and its uneven distribution on the roller. I added touches of emerald green watercolour with a soft brush on various parts of the painting.

Fig. 2 Here raw sienna watercolour has been rolled over 200lb Bockingford paper and then purple paint has been superimposed in parts. A third colour, warm brown, was created where the first two colours overlapped. Onto this random ground I have drawn a group of buildings using pastel pencils of various colours – greys, white, red and brown. The painting is deliberately not completed in order to show the development process. Some of the painted edges required adjustment by blending or covering them with pastel pencil or with more paint, and some of the painted edges were left, having fallen fortuitously into place as the drawing progressed. These chance effects are observed and a choice is made as to their usefulness in the painting.

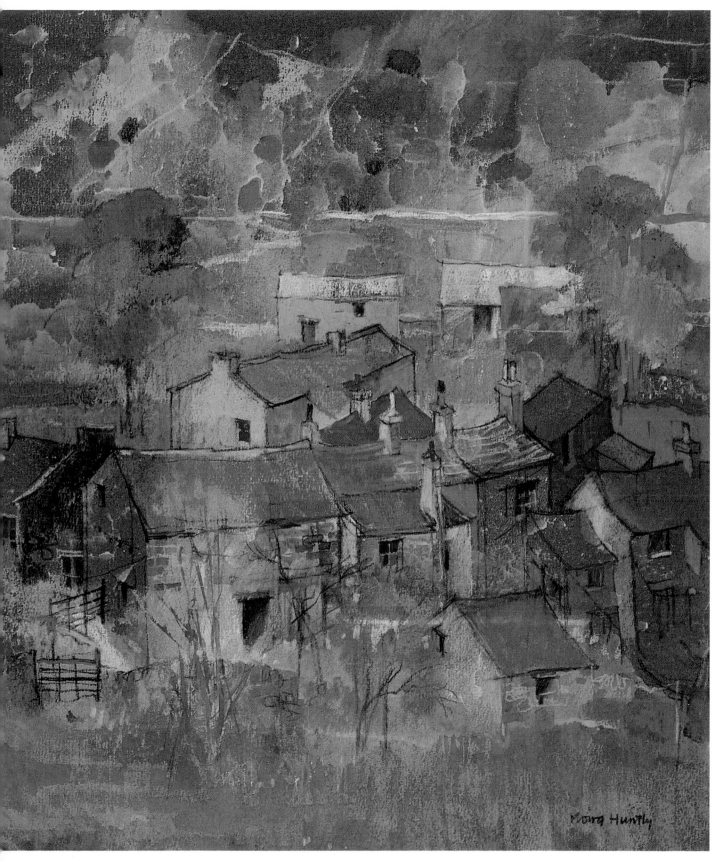

Village in the Yorkshire Dales $15'' \times 13\frac{1}{2}''$

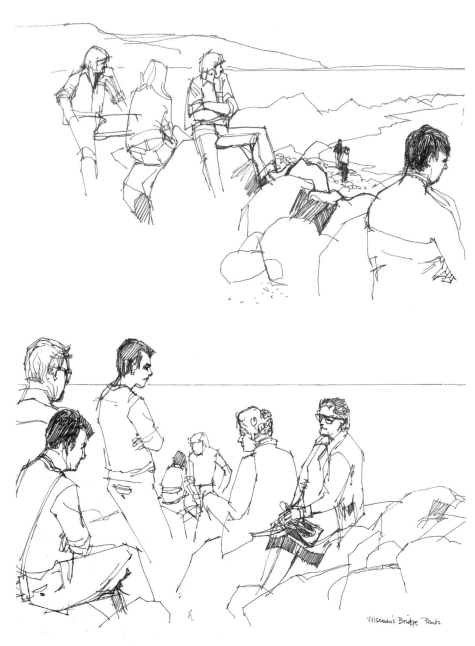

Watercolour, gouache and pastel pencil

Figures on the Rocks

The choice of a bright pink pastel paper for this painting of the coastline was a bit of an experiment. *Stage 1* shows the roller technique on the background, using permanent magenta watercolour and fairly dilute cadmium orange gouache, all of which created a very bright warm basis that became a strong influence throughout the painting. Dark green gouache was rolled across the central band in the painting where I intended to place the main group of rocks.

My seaside sketches were used as the starter for this painting. Without adhering too rigidly to any particular one, I used them as reference material, taking information from here and there and incorporating it into the composition. The placing of the horizon was an early decision; I deliberately placed it high to allow space for the rocks and figures which were my main interest.

Wiseman's Bridge Pemb.

'82

When the underpainting was dry, I started to draw with dark green and blue pastel pencils which stood out in contrast to the warm background. Dilute white gouache was brushed over the sky and much of the pink ground shows through, glowing through the cooler film of white paint.

Then I established the tones on the water and some of the darker rocks with thin washes of olive green, lamp black and purple gouache. This band of dark helps to tie the figures together, and the warm pink colours glow against it.

The colour of the underpainting was refined with shading and cross-hatching, using light tones of pale grey, pink, pale orange and green pastel pencil, leaving the strongest areas of underpainting to show on important areas such as the girl's sweater.

Detail

Figures on the Rocks $12\frac{1}{2}'' \times 15''$

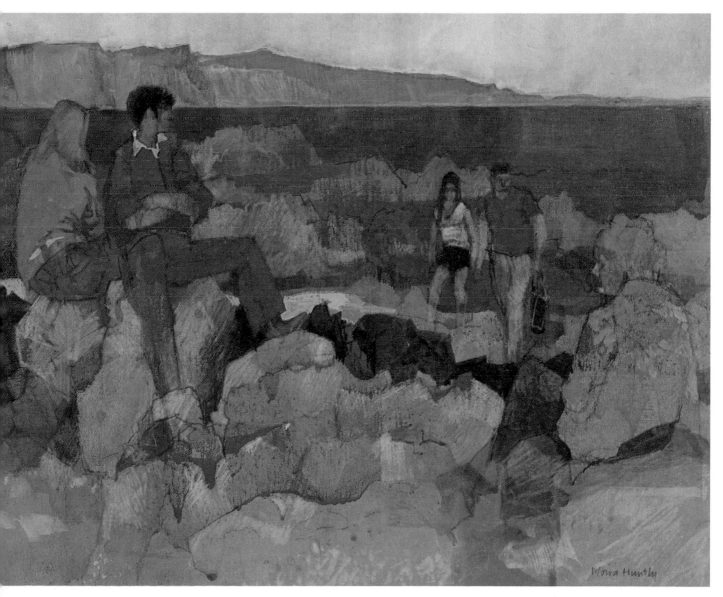

Oil paint, turpentine and pastel

Earlier in the book I discussed the process of working with pastel on a watercolour base. Oil paint on paper also makes an interesting base for pastel work. The oil paint is prepared, so that it dries with a matt velvety surface that is extremely pleasant to work on. The paint should be as dry and free from oil as possible, in order that the ground dry quickly, allowing pastel to be applied without the effects of moisture, which would change its surface character.

Oil paint can be made stiff and dry, to a certain extent, by squeezing it out of the tube onto blotting paper and leaving it overnight. Next morning the spread of oil surrounding the pigment can be seen on the blotting paper. Then the paint is mixed with a little distilled turpentine and brushed onto heavy cartridge paper, Ingres board or strawboard. When the ground has dried out, pastel can be applied broadly in patches of flat colour, or stippled and cross-hatched over the paper, allowing the oil painted surface to break through the applied pastel. Further variations in the surface appearance of pastel can be achieved by brushing it into the prepared ground with a stiff hog-hair brush, or by scratching areas of thick pastel with a razor blade so that the ground shows through.

Degas was constantly experimenting with mixed media and used this process (known as *peinture à l'essence*) to create extremely exciting atmospheric effects, especially in his paintings of the theatre.

Preparing a ground, using oil paint as a base for working in soft pastel

Oil paint on blotting paper

Leave overnight. Blotting paper absorbs the oil to a certain extent.

Oil paint and distilled turpentine

Add a small amount of distilled turpentine to the oil paint to help it to flow, and apply with a hog-hair brush onto a heavy cartridge paper. Have newspaper underneath to absorb the turpentine,. Leave at least a day to dry out.

Soft pastel on top of prepared ground.

Allow some of the ground to show. Degas used this method for some of his pastel paintings, particularly of ballet dancers.

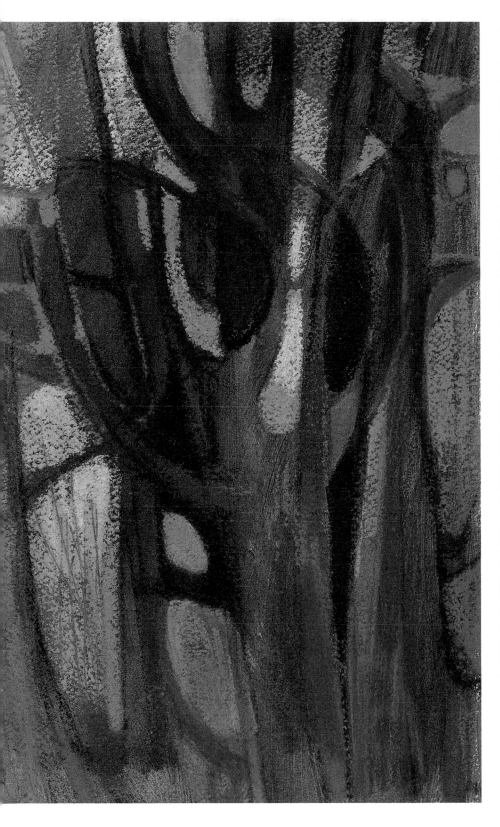

Tree Forms $11\frac{1}{2}'' \times 7\frac{1}{2}''$

My rather stylised painting of trees was made on heavy watercolour paper, and the ground was prepared with mixtures of viridian and crimson oil paint and distilled turpentine. Because these grounds take time to prepare and dry out, I will often create several of them at once.

The tree shapes were outlined with warm-coloured pastels, madder brown and reddish purple, and the spaces between the tree trunks and branches were blocked in with various light tones of green pastel – grass green, brilliant green, viridian and lizard green. These spaces, which are called 'negative shapes', have been made colourful and light in tone to make a contrasting impact that will also emphasise the curved shapes of the tree forms. The effect of sparkling light is enhanced by dragging the light-toned pastel over the textured paper so that the contrasting dark underpainting breaks through. In places I scraped and scratched lines of pastel away with a sharp knife to reveal the underlying oil ground.

Some of the tree forms were darkened with purple pastel and deep Indian red pastel, and enriched with touches of olive green. In parts, the oil ground was left untouched and the broad brush strokes are visible. The combination of matt oil paint and smooth brush strokes, with the more pronounced texture of the pastel, is an interesting one which creates a very varied surface.

Oil paint, turpentine and pastel

I used a thick piece of Ingres board as the support for this underpainting, and the oil ground was prepared as previously described.

This time the ground has a warm bias, and I used burnt sienna and lamp black oil paint with a hint of Prussian blue.

A random underpainting such as this can sometimes suggest the subject, and in this particular example I can imagine figures. On the upper right corner I can see a woman's head with long hair and a long neck, and there is the suggestion of a smaller figure on the left.

The potted variety of fern shown opposite was painted on a similar warm ground. The reddish colour is a contrast to the green of the plant.

Natural greens have a certain degree of subtle warmth in the colour and in this case some of the green pastel is applied lightly and the red glows through.

The red is also shown where veins have been scratched with a knife on some leaves. A scratched line was also suited to the angular quality of the crumpled paper around the pot. Here the treatment of pastel is varied, some dragged broadly across the paper while some areas are rubbed into the oil ground, giving a soft filmy effect.

Leaving areas of the ground show-ing can unify a painting because patches of uniform colour are repeated throughout.

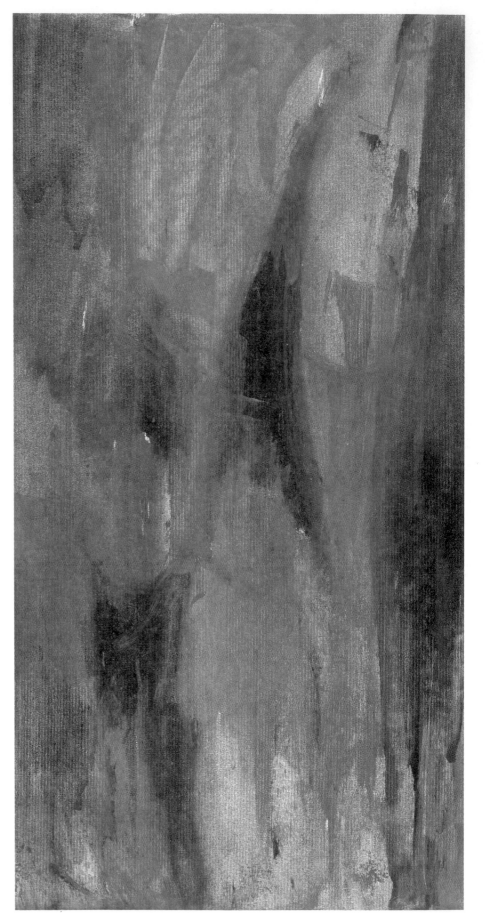

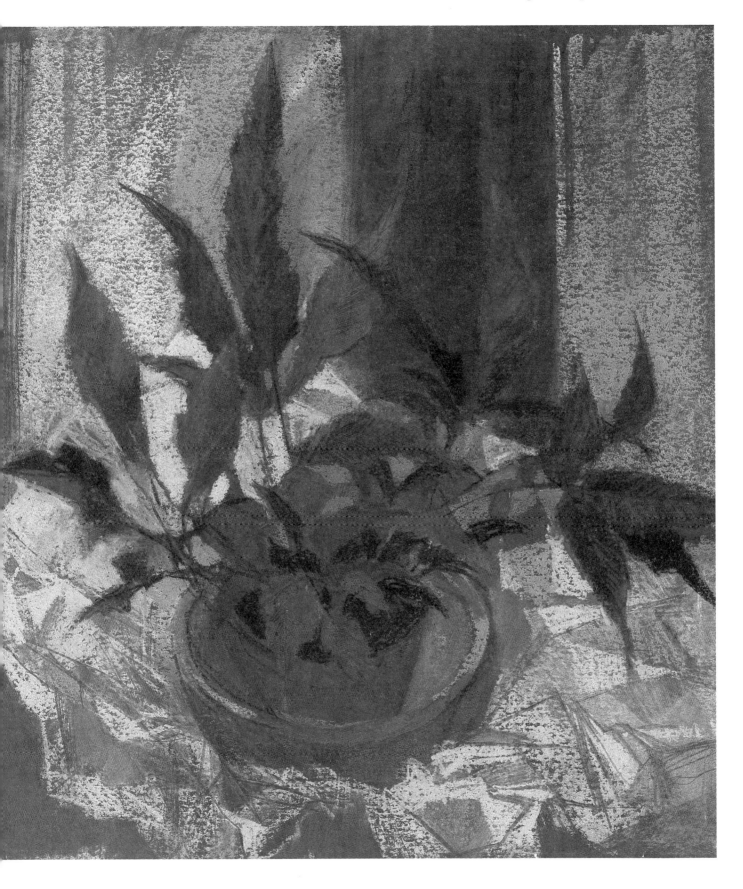

Fern in a Pot $11\frac{1}{4}'' \times 10''$

Oil paint, turpentine, conté pencil, pastel pencil and pastel

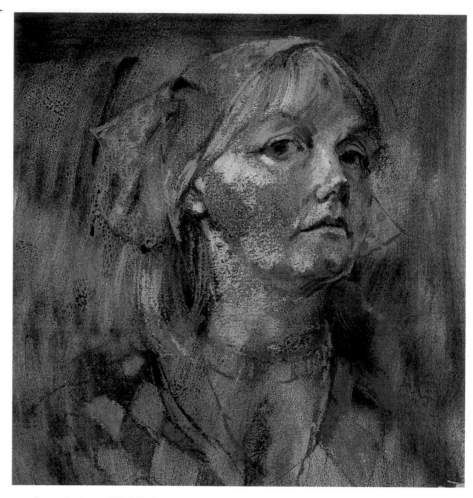

Self Portrait $11\frac{1}{2}'' \times 10\frac{1}{2}''$

Here the support is watercolour paper treated with varying tones of Prussian blue oil paint. In places the ground shows a pronounced and interesting mottled appearance. I cannot be certain as to the cause, but it was probably due to the ratio of distilled turpentine to oil paint and the amount of oil remaining in the paint after it had been subjected to the blotting paper treatment.

The head was lightly drawn with red conté pencil, and then the various planes of the face were painted with the side of the pastel, using the lightest tones of burnt sienna and purple grey and dragging them over the blue underpainting. Highlights were created by pressing the pastel onto the paper to fill the grain, but elsewhere the pastel strokes were applied with light pressure, allowing the ground to break through as areas of blue shadow. Very often the shadow tones of a face can be cool in colour, and the whites of the eyes are rarely seen as white. The drawing of the eyes and nostrils was reinforced with dark grey pastel pencil.

The choice of blue for the underpainting was especially appropriate because it happened to be the colour of the sweater and head scarf. The pattern on the scarf was indicated with pale blue and green pastel but it relies very much on the underpainting. The clothing has a diamond pattern shown partly by outlining the diamonds with blue pastel, and filling some in with pastel and leaving others as the blue ground. The light colour of the hair is suggested with touches of warm grey, green grey and a dark tone of yellow ochre.

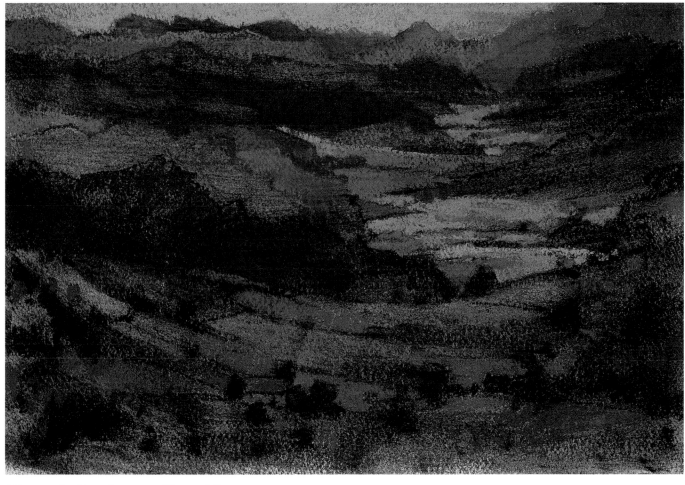

Mountain Landscape $7\frac{1}{2}'' \times 11\frac{1}{2}''$

This painting relies very much on the prepared oil ground, which consisted of a mixture of blue grey and burnt umber. The consistency of the paint was very dry, and the paper coarsely grained, which created dry-brush effects and an uneven distribution of paint in dark blotches over the surface. I retained most of these dark blots in the final painting as tree shapes, and also added a few more of them with very dark burnt umber and purple-grey pastel. In the distance the under-painting was modified with strokes of pastel in various tones of blue grey and warm grey and a few outlines added with pastel pencil.

The main impact of the painting is localised in the middle distance with light tones of pastel pressed firmly onto the support. The fields in the foreground are painted with darker tones of the same pastel colours used on the light areas of the valley floor.

Offset prints and oil paint

This oil-based ground is created by an off-set process. Again, supports can be varied, including oil paper, pastel paper, Ingres board or thick cartridge paper. Various media can be incorporated such as charcoal, conté, soft pastel or oil pastel.

Oil paint is squeezed from the tube onto a sheet of glass or smooth-surfaced plastic and spread with a brush moistened with turpentine. The chosen support is then laid face down onto the glass and the back of the paper smoothed over with the side of the thumb or the back of a spoon.

Fig. 1 I used a smooth cartridge paper and the brush marks can be clearly seen.

Fig 2. shows the same process using pastel paper as the support; the resulting off-set print is strongly textured and uneven.

Fig. 3 shows the effect of dropping a little turpentine here and there onto the surface of the glass before placing the support. This gives a mixture of textured paint and a softer wash effect.

Fig. 4 Thin Ingres paper was placed on the painted glass and, instead of being rubbed over the back, it was

Fig. 1

Fig. 2

Fig. 3

Fig. 4

brushed over with clean turpentine. The paper became porous and instantly transparent, showing the softening effects as the turpentine mixed with the oil paint.

I leave these rather oily grounds to dry for a day on newspaper, which absorbs any excess oil.

Fig. 5 Oil paint was applied to glass and then drawn into with a turpentined rag. Then an off-set print was taken.

Fig. 6 A second print was taken off the same image painted for *Fig. 5*. This time there was less paint left on the glass, and the resulting print was softer and more subtle.

Fig. 7 The paper was placed onto the oil painted glass as usual and a line was drawn onto it with the handle end of the brush (alternatively a pencil or biro could have been used). Where pressure was applied from the end of the point the oil paint was picked up

onto the paper and is seen as a dark line. In other areas of this image some oil paint became deposited onto the paper as the result of gentle contact

Fig. 8 The piece of glass of *Fig. 7* will retain some of the oil paint, except where the line of paint has been removed by drawing. If a new piece of paper is laid on the glass and the back rubbed over, the paint will be off-set and will leave a light line which in effect is a negative image of *Fig. 7*.

Fig. 5

Fig. 6

Fig. 7

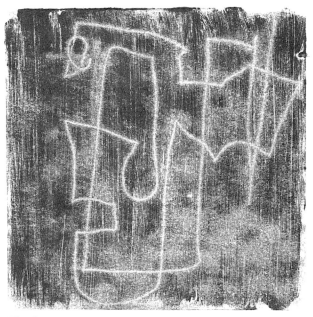

Fig. 8

Oil paint, turpentine, charcoal and pastel

These ideas can form the basis for future paintings, and can be combined experimentally with various other media. My painting 'Socket and Spanners' is worked on a subtle ground of off-set oil paint, with turpentine wash in some areas giving a mottled effect on a cream-coloured Ingres paper. When the oil paint was dry, the spanners and socket were drawn with charcoal and then sprayed with fixative. Subtle colours were introduced onto selected areas, using soft pastel, and the painting was then given a final light spray of fixative.

Fig. 1 Two colours were painted onto the glass with a small amount of turpentine, and an off-set print taken on textured Ingres paper. The resulting image conjured up an illusion of clouds above a group of trees. When the print had thoroughly dried I emphasised this illusion by the addition of a little touch of pastel pencil and gouache.

Fig. 2 One colour plus turpentine on glass and off-set onto cream-coloured Ingres paper. This time I could imagine a figure with a floppy hat, so I added some drawing with pastel pencils.

Fig. 3 This shows how the painting of spanners was started, with a strong charcoal pencil drawing superimposed onto the prepared oil ground. Where possible, some of the random marks in the mottled texture of the background are incorporated into the positioning of the subject.

Fig. 1

Fig. 2

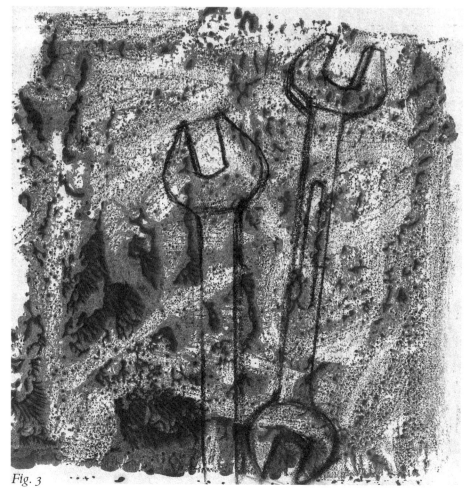

Fig. 3

Socket and Spanners $8\frac{3}{4}'' \times 7\frac{1}{4}''$

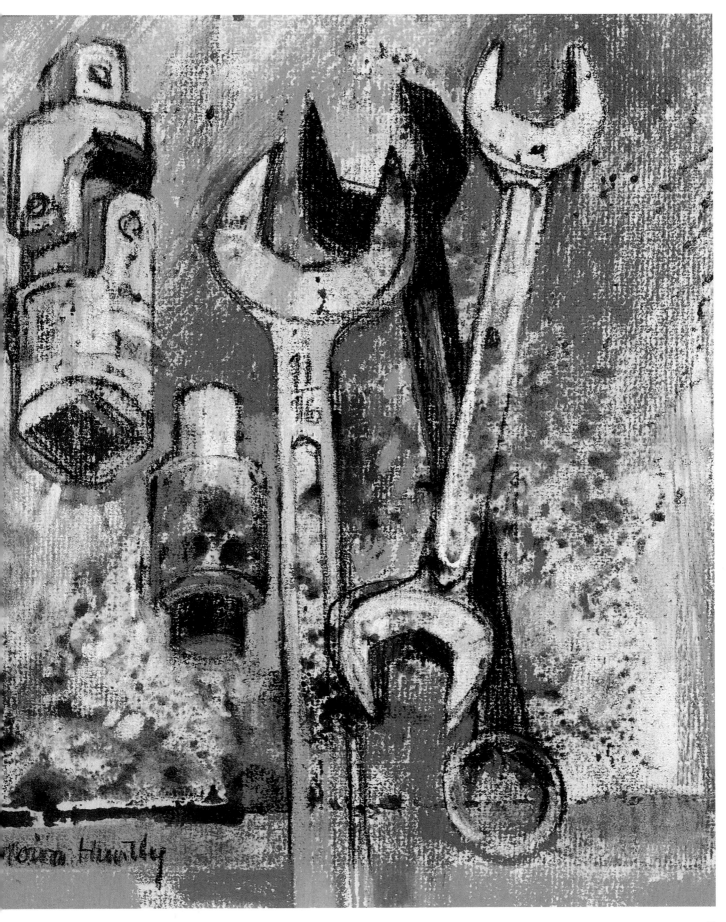

Marbling with oil paint, turpentine and water

The technique of marbling provides another method of creating an interesting random textured ground on which to paint. Other media can be incorporated with it in a similar way to the off-set oil grounds already described.

Marbling relies on the fact that an oily substance will float on the surface of water and not mix with it. The simple examples of marbling shown here require only a minimum of equipment. A small tray, water, oil paint, turpentine and paper. The method I employed was to submerge a piece of paper in a tray of water, and then oil paint thinned with turpentine was dribbled or flicked on to the surface of the water. Then I carefully lifted the paper up and, as it broke the surface, the oil paint floating there was caught onto the paper. The results of this technique are totally unpredictable, but nevertheless exciting, and its effects stimulate the imagination.

An alternative method of transferring the floating oil paint is to lower the support carefully onto the surface of the water for a few seconds. The paint is immediately picked up by the support, which is then gently lifted off the water, and the image that is revealed when it is turned over can sometimes be quite dramatic.

Fig. 1

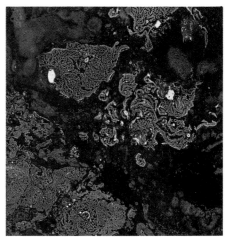

Fig. 2

Fig. 3

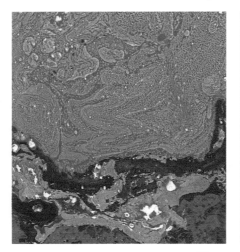

Fig. 5

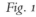

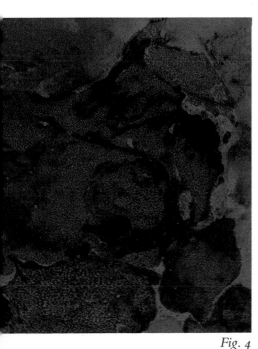

Fig. 4

Fig. 6

Fig. 1 Emerald green and white oil paint dispersed over the surface of water and caught onto thin white paper. The result is reminiscent of swirling, frothing sea foam around the rocks.

Fig. 2 This is the same emerald green oil paint, giving a more subtle result on a piece of dark brown card.

Fig. 3 Emerald green, ultramarine blue and white oil paint on brown card. Some of the oil paint had been thinned with turpentine, but where a few globules of thick paint occurred, these are seen as solid blobs of pigment. In this example the thickest paint is white.

Fig. 4 Emerald green and ultramarine blue on ochre-coloured pastel paper. I looked hard at this image and suddenly saw a reclining nude torso; now I cannot imagine anything else as an alternative image. Perhaps you can.

Fig. 5 This image evokes feelings of an ancient barren landscape, the heavens above dotted with stars. Once again I have used emerald green and white paint on a yellow-ochre ground.

Fig. 6 I call this one, green poppy field (in bud), and have added little touches of detail with a pen and white ink. This is also white and emerald green paint on white paper and was part of the same batch as *Fig. 1*, yet the image resulting is quite different.

Oil paint and conté pencil

Drill and Spanners

Subject matter is a personal thing, and mechanical subjects hold a fascination for me. I observe dynamic shapes and constructive relationships in their strong lines and smooth curves. A man-made object of good functional design is often also aesthetically satisfying with good structural form.

The conté pencil drawing of the vice and tools is a simple constructional drawing, defining the outline shapes of the tools and observing their relationships as accurately as possible. I search for the formal, more abstract qualities to be found in every subject and I should point out that, in this drawing, I placed the vice deliberately upside down, because as an abstract shape I preferred it this way, and found it more satisfying to draw.

It appealed to me to combine strong, sometimes sharp-edged shapes of tools with a rather nebulous background of sporadic texture. The marbling effects that form the basis for the painting 'Drill and Spanners' are not too pronounced, but are just enough to suggest sawdust and spillages of oil on a workbench, in keeping with the subject of tools.

The painting started on a lightly marbled ground using burnt sienna, raw sienna and black oil paint on a heavy cartridge paper and allowing the paint to dry out for at least

twenty-four hours before commencing to draw. I drew with dark grey conté pencil and then sprayed it with fixative. This helped to size the paper and allowed further washes of thin oil paint to be added to the tools, giving them tone and solidity against the background.

I regard this painting as a study for development into a series of paintings based on circular shapes, combined with subtle curves and angular lines, plus the texture of the initial oil ground.

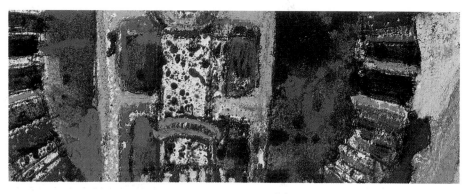

Detail from **'Drill and Spanners'**

Tools on the Bench

Drill and Spanners
$12\frac{1}{4}'' \times 7\frac{1}{4}''$

Fishguard $8\frac{1}{2}'' \times 14''$

Ink drawing with watercolour wash

Line-and-wash is the most common way of using ink and watercolour, and I find it very useful for sketching. I do a lot of drawing on site, sometimes using pencil and sometimes a pen. The choice is fairly arbitrary, but I would certainly not attempt to record fine detail with a broad felt-tip pen! Pencil can give a fine line or a softer smudgy line, whereas a pen gives a very definite decisive line. Occasionally I use an ordinary dip pen with a bottle of Indian ink, but for outside work, a pen containing ink (sold at any art shop) or a felt tip pen is more convenient. It is important to realise that some of these pens contain waterproof, light-fast ink; in others, including felt-tip pens, the ink is water soluble and will fade. This does not matter for a working drawing.

Sometimes after I have completed a drawing, I wash watercolour over it quite quickly without any special attempt to confine the colour within the lines. Very often the colours flow into each other and provide a continuity that unifies the drawing. The drawing itself sufficiently describes the form of individual parts. When watercolour is washed over a felt pen drawing, some of the pen work will run, depending upon the wetness of the wash. This effect can be quite pleasing, and helps to integrate the drawing with the colour. Occasionally I use waterproof ink and non-waterproof ink on the same drawing and this can give an interesting mixture of precise line and blurred line where the non-waterproof ink has dissolved into the wash.

These loose washes are useful because they enable me to register the colours and tonal variations of a subject very quickly. They are also particularly useful in recording fleeting effects of light and shade.

Leaves

Fishguard

The little sketch shown opposite started with free watercolour washes and no preliminary drawing. Then I used Indian ink and a dip pen to draw the houses and boats and hints of foreground detail.

The initial broad areas of colour were applied in relatively flat washes, with little attempt at detail modelling. The work relies on the pen-work to contain and explain the details.

Indian ink was brushed onto the background behind the row of houses, and onto the doors and shutters. Dilute ink was used for areas of shadow and on the foreground details.

Finally, I brushed clean water onto some areas of the foreground and dropped dilute ink into it, giving a diffused effect as the ink dispersed on the surface of the water.

Ink and wash sketches

Rhiconich, Sutherland, Scotland

The distant hills were drawn with a fine black Edding waterproof pen, and all the other lines with a broader black felt-tip pen. The watercolour washes have slightly blurred the drawing except where I used less water in the mix, as you can see on the strong dark rocks at the top right. These washes were insufficiently wet to disturb the felt pen lines.

Scarfskerry, Caithness, Scotland

Nearly all the outlines in this sketch were drawn with a brown felt-tip pen and the tone of the buildings was massed in with a broad grey felt-tip pen. Watercolour was washed over some of the buildings and across the fields. When the washes were dry some details were added with a very fine black felt-tip pen.

Rhiconich, Sutherland 11″ × 16″

Scarfskerry, Caithness 4″ × 16″

Gravestones, Pembrokeshire, Wales $12\frac{1}{2}'' \times 11''$

Again, this sketch is a combination of waterproof and non-waterproof inks with watercolour washes. The texture on the right-hand gravestone was made by pressing my thumb into the paint before it had dried.

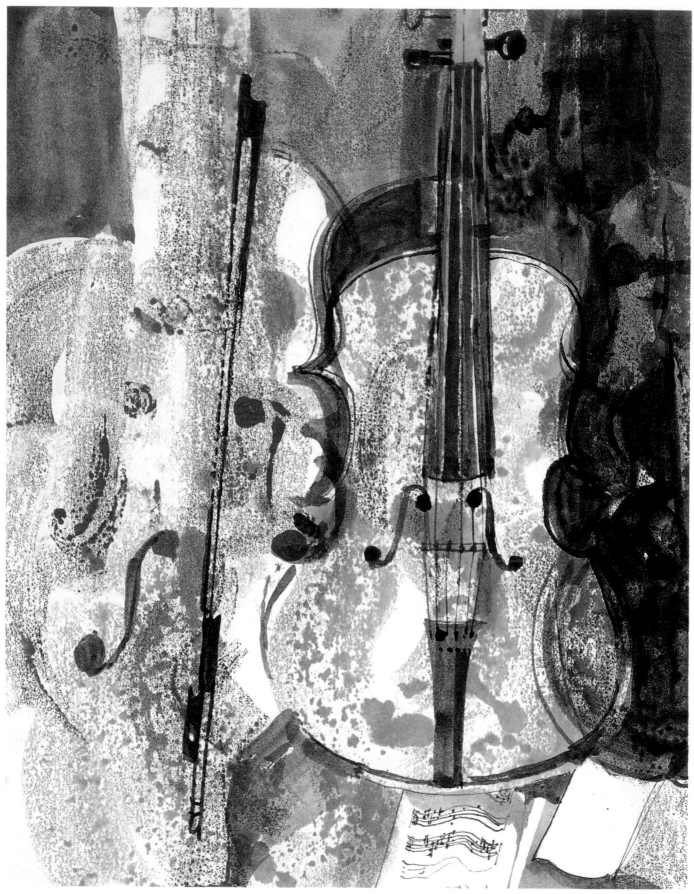

Violins $10'' \times 7\frac{1}{2}''$

Ink on watercolour monoprint

Violins

Textures feature in this painting based on the intriguing shapes of violins. Here I have used watercolour applied by a monoprint technique as well as with a brush. The textured wash provides an interesting contrast to the precision of a fine pen and ink line.

Musical instruments are complex objects, and so I made a pencil study in order to explore the characteristics of the violin. The subtle curves and form of the instrument required some keen observation, and in trying to record the shapes accurately I found the violin tantalisingly difficult to analyse. Occasionally the curves flatten unexpectedly and then change direction in a very subtle way that I really only discovered during the process of drawing. The shape of the pegs at the top has both a roundness and a certain amount of angularity, and it is slightly concave in an unexpected direction. The shape of the scroll was interesting to draw; it spiralled in one plane and was concave in another plane.

The painting started as a watercolour monoprint, producing the mottled background which possesses a print quality which I find pleasing. (The technique of making a monoprint is more fully explained on page 60–61). Details were added with ink, sometimes using a thin brush or a fine dip pen.

Aline: study for a portrait

(acrylic ground, pastel pencils and pastel)

This drawing was made on a prepared ground, for which I used cadmium red acrylic paint thinned with water, and applied it freely with a very broad brush. Thin acrylic is quickly absorbed into the surface of the paper and dries immediately with a matt quality. The brush strokes are very evident and give an interesting relief to a large area of colour.

The head was drawn with grey pastel pencil and the facial features slightly modelled with pink and white pastel pencil. In contrast to this delicate modelling sleeves and collar were drawn boldly with white pastel.

These techniques were prompted by the traditional methods of past masters such as Leonardo da Vinci, Rembrandt and Holbein, who often worked their drawings on coloured gesso (plaster) grounds or tinted papers using red, black and white chalks and silver point. The coloured grounds varied between pink, yellow, green, dark red, purple and blue. Leonardo in particular was an innovator of drawing techniques, being the inventor of pastel and the first to use red chalk. I thought of white pastel and pastel pencils on an acrylic prepared ground as a modern application of this older approach.

Ink, watercolour, conté pencil and gouache

Portrait of Aline

The monoprint technique is seen quite prominently in the background and on the dress in this portrait of Aline. The monoprint was produced with cadmium red watercolour brushed onto glass; a small amount of Indian ink was also dropped onto the glass and a sheet of paper pressed gently onto the surface, resulting in a textured mottled surface all over it.

When this was dry I outlined the head with conté pencil and then modified the area behind the head with a wash of pale-green watercolour. Most of the dress was left as the original print, except for a few blotches of orange gouache added to emphasise the pattern. The lace collar was developed with a brush and white gouache, leaving some of the pink underprint showing. The face was painted almost entirely with gouache covering most of the monoprint, and the hair painted with washes of dilute Indian ink. The use of monoprint helps to unify the background and the dress, and is also useful in providing a decorative pattern in contrast to the painted features of the head.

Aline (Drawing) 19″ × 12¼″

Portrait of Aline 9¼″ × 7½″

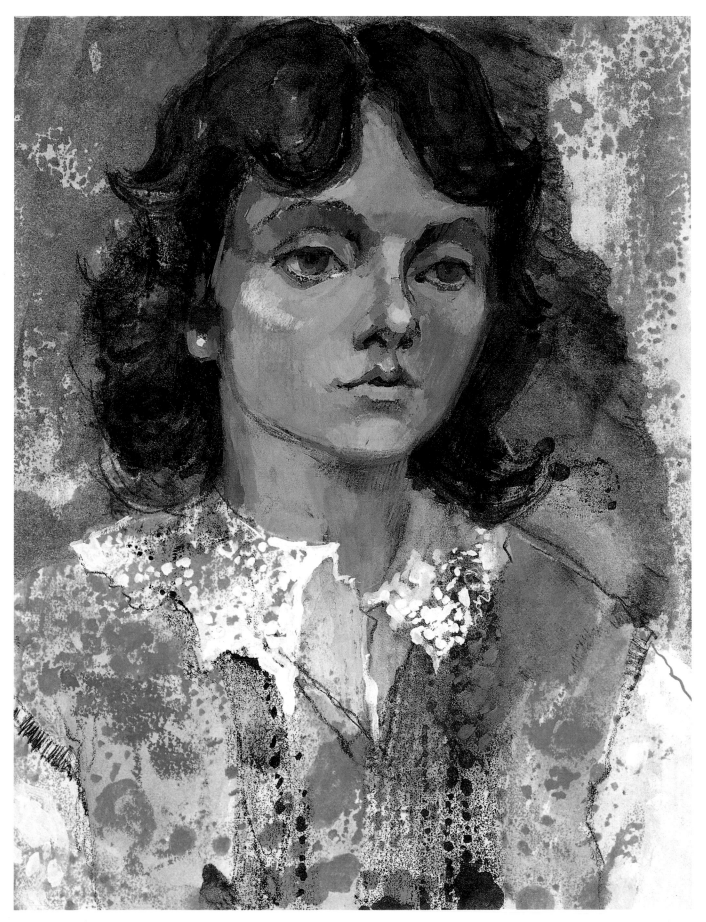

Ink blots

Here are examples of a few of the marks that can be made with ink.

I have used black or white ink throughout the book because they are the only inks guaranteed as permanent.

Fig. 1 Obvious blots dropped from a large brush, full of Indian ink.

Fig. 2 Blots again, this time allowed to dry partially before being washed over.

Fig. 3 A large wet ink blot that has been blown gently in different directions with a straw.

Fig. 4 Ink blots dropped onto wet paper; the ink flares and some of it spreads out to the edge of the damp area.

Fig. 5 White ink blots on top of dry black ink.

Fig. 6 White ink blots dropped onto wet black ink, giving a grey mottled appearance.

Fig. 7 Rubbing with the side and drawing with the end of a piece of stick.

Fig. 8 Drawing with a pen on wet paper. The line is fuzzy and the ink spreads, producing a granular effect in places.

Fig. 1

Fig. 2

Fig. 3

Fig. 4

Fig. 5

Fig. 6

Fig. 7

Fig. 8

Ink, watercolour and gouache on toned paper

Abercastle, Pembrokeshire

This started as an Indian ink drawing, made with a pen and stick on the smooth side of mid-grey Canson paper. The stick gives a line that is less precise than the pen, creating a softer, more variable quality of mark. Dark tones were established with watercolour washes, all sombre in colour, as the particular lighting effects of that day dictated. Chimneys and roofs seemed almost black against the sky, and this strong contrast was emphasised by the introduction of white gouache. The sketch immediately came to life with this added sparkle of white.

Plant Doodle

This time the work proceeded in the opposite sequence. Watercolour washes were freely painted onto mid-grey pastel paper and then the drawing, with a dip pen and Indian ink, was superimposed over the washes. Finally, the flowers were added with a brush and white gouache.

Plant Doodle

Abercastle, Pembrokeshire

Ink and pastel

North Wales Landscape

This painting was made on the spot, working out of doors. I was attracted by the positive shapes of the group of buildings and their feeling of solidity, and by the way in which the foreground wall and road curved round, leading into the picture and threading its way between the buildings. I was also attracted by the link in tone and colour between the dark roofs and walls and the slate-coloured distant hills.

The smaller illustration shows a reconstruction of how the painting was begun on a piece of heavy Bockingford watercolour paper. To achieve the basic movement and form in the painting I used a brush and black Indian ink, sometimes dipping the brush into water to soften and lighten the tones. I used a sharpened piece of stick dipped into the ink for the finer line work and a brush for thicker lines. The ink work was put on boldly, with emphasis on the sweep of the landscape and general structure of the buildings, rather than trying to produce a refined drawing. I knew that the ink work could be modified and partially covered by a subsequent layer of pastel.

My next step was to brush washes of watercolour over the paper. This provided colour and tone to link the elements in the painting, as well as killing the white of the paper, which can glare painfully when working outdoors. I started with a wash of olive green and added burnt umber in

North Wales Landscape
$13\frac{1}{2}'' \times 21\frac{1}{4}''$

parts to add warmth. These washes were quickly applied without attempting to confine them to particular areas of the drawing, in fact some of the watercolour spilled into the sky and onto the inked parts.

When the paper was dry I added passages of pastel, strips of acid green light on the field around the buildings; blue greys on the distant black hills; darker green and orange-brown in the middle distance, and white and mauve over the buildings. The black walls were modified with grey pastel and the foreground was lightened with broad sideways strokes of pastel. Further subtle modifications were made in some parts by working with dark pastel colours over the black ink; in other parts the ink was worked over with light pastel. This is particularly noticeable on the white building, where the white pastel is emphasised by the dark tone breaking through. Light pastel dragged over a dark underpainting is very effective.

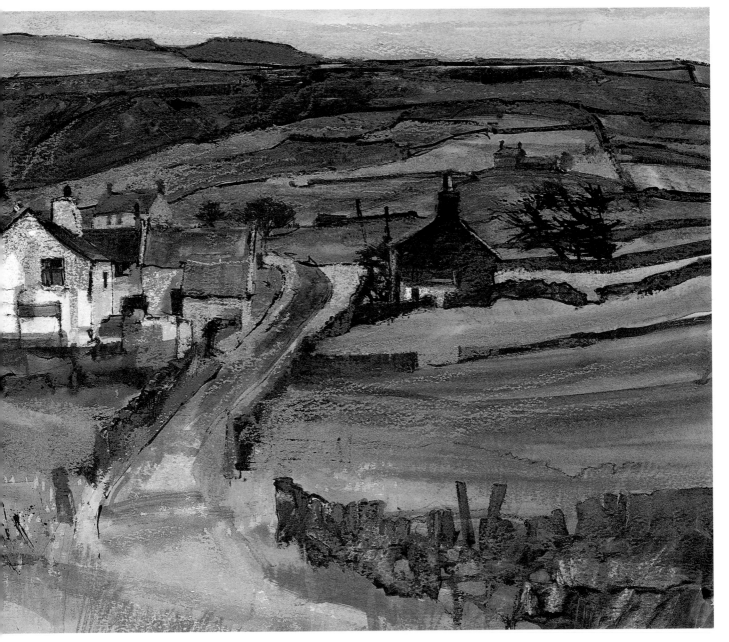

Ink, watercolour and other media

Ink, watercolour and pastel pencils on toned paper

Oxford Street, Abertillery, Wales

There was a sadly derelict air about this empty corner building; built in Victorian times, it had obviously seen better days. The classical beauty of the architecture remained and I was attracted to the facade, particularly the shape of the pediments and cornices at its very top.

Stage 1 I made a sketch on toned paper with a charcoal pencil, and tried to keep the long vertical lines truly vertical by comparing them from time to time with the vertical edge of the paper. I was not able to stay long enough to do a finished painting on the spot, for it was about to rain, so I quickly added colour washes and indicated the variety of coloured bricks with pastel pencils.

Stage 2 A few weeks later, I came across the sketch in the studio, and remembered the darkening sky advancing before the rain storm, and the way it dramatised the top of the building. At *Stage 1* the building is dark in tone against the sky and I had thought of darkening it further and making the sky light, to emphasise the angles of the pediments. This would also have dramatised the skyline, but might have lost some of the details. As you can see, my memory of the elements won the day, and I decided to make the sky really dark. In preparation for this I poured some Indian ink into a china palette, and some clean water into a jar. I began by washing clean water over the sky, carefully brushing the water around the edges of the building. When doing this it is helpful to work with the painting upside down and inclined at a slight angle, so that the water tends to run away from the buildings and not over them.

Stage 1

Oxford Street, Abertillery $19'' \times 11\frac{1}{2}''$

Working swiftly so that the sky area remained wet, I dipped a large brush into the ink and painted the sky, commencing once again with the building outline. Some of the ink ran down and flared into the water on the sky area, dispersing and diluting in parts, depending on how wet the paper had remained. The effects are pleasing though not entirely controllable. After the sky had dried, I turned the painting up the normal way, changed to a smaller brush, and painted some of the windows with Indian ink. Details, especially on brickwork, were added with pastel pencils, and finally a light wash of Prussian blue watercolour was painted over the ink on the sky as a colour link with the blue paintwork on the buildings.

Ink and gouache

Tewkesbury

Tewkesbury in Gloucestershire is rich in architectural features; even the back view of this row of houses is full of interest. Unusually tall chimneys and gradual additions to the houses over the centuries provide a wealth of visual stimulus. Red and orange brick, crumbling pink plaster and black timbering dominate the townscape, and this led me to exaggerate the colour theme in my illustration by extending it into the sky and foreground rubble.

With texture very much in mind, I chose a dark-toned Ingres paper and worked on the side with the most pronounced tooth. I used a large plastic palette and mixed white with a little of the Tyrien rose gouache, and instead of using a brush I applied the colour onto the paper with a $4\frac{1}{2}''$ roller, which explains the need for a large flat palette, big enough to accept it. I worked the roller back and forth over the paper until no more paint was being deposited. These last sparse areas of paint allowed the paper to show through and emphasise the texture.

This roller process was repeated with a mixture of cadmium orange and white, and once again with dilute Tyrien rose and a touch of lamp black. This created a random background on top of which I made a pen and ink drawing of the buildings. Details have been added here and there, painted with a small sable brush and a variety of thin or thick gouache. Cadmium orange with a small amount of black makes an interesting warm brown, that can be varied with the addition of white. Similarly, black and/or white added to Tyrien rose will give a variety of warm greys. I used these colours on some of the chimney stacks and brickwork, and on the building at the rear. A filmy layer of dilute white gouache was brushed over a building on the left, allowing some of the paint underneath to show through, giving a soft mottled quality to the wall. Such areas serve as a nice foil to the more strongly textured parts of the painting such as the pale pink wall on the right of the foreground. Here the tooth of the paper is clearly seen, looking rather like wire mesh.

It is an interesting exercise to make a tight, almost precise, drawing on a freely textured background and then select areas of texture to be retained and gradually soften other areas. The details are also a mixture of precisely painted areas and broader 'accidental' textures, but as the painting progresses we make choices about what part to retain and what to discard and so the final result is not an accidental painting at all.

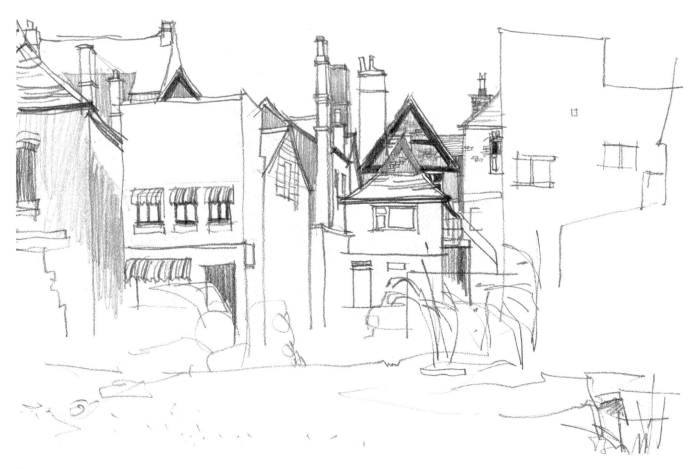

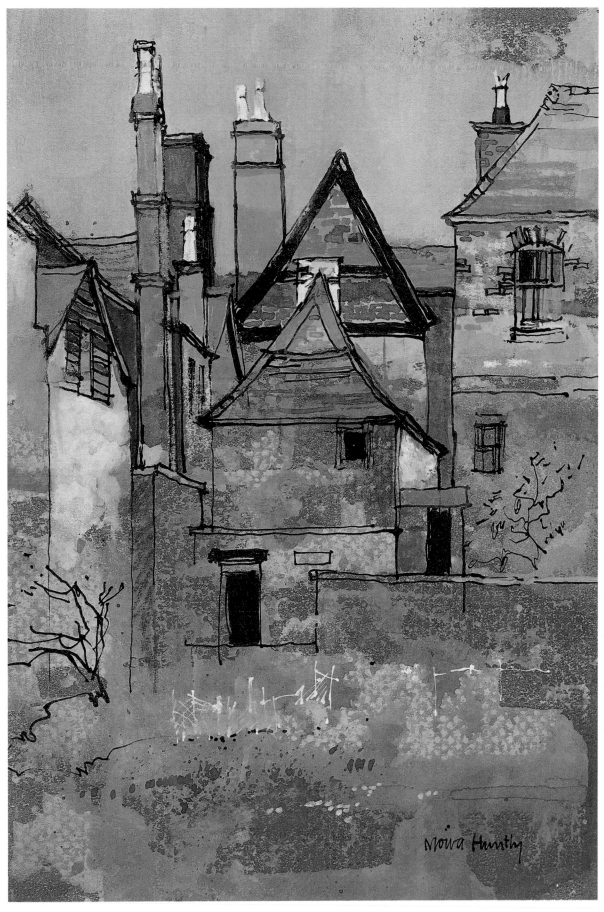

Tewkesbury
$8\frac{1}{4}'' \times 5\frac{1}{2}''$

Ink, gouache and pastel pencil on toned paper

Rocky Coast, Pembrokeshire

Here again I am using the textured side of a dark-toned Canson Mi-Teintes pastel paper and a roller base for this painting of a rocky coastline. To begin, I moistened a roller with clean water and then dropped some ink onto it and rolled it over tinted paper. The result can be seen in *Fig. 1*, where the ink was deposited in such a way that it left a rock-like sharp-edged line in keeping with the subject. In *Fig. 2*, very dilute ink mixed with a touch of white gouache has been applied with the roller, giving a softer more subtle effect.

The painting opposite began in this way, the roller marks suggesting rock forms very similar to those in my sketch. I developed this theme by adding some drawing, using a stick dipped in Indian ink to give an uneven ragged line, which retains the feeling of a rugged coast. Light-toned areas were introduced with opaque gouache paint. This can effectively be used on toned paper, covering it entirely in places and using it as a dilute film in other parts. The sea was also defined with gouache and hints of warm colour and a few details were added to the rocks with coloured pastel pencils. In other places the dark green of the paper remains untouched as part of the painting. It is important to use a good quality light-fast paper if part of it is to be left showing.

Fig. 1

Fig. 2

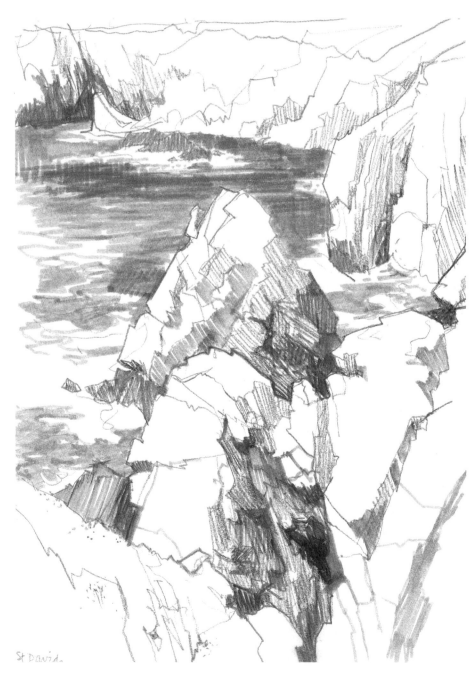

St David.

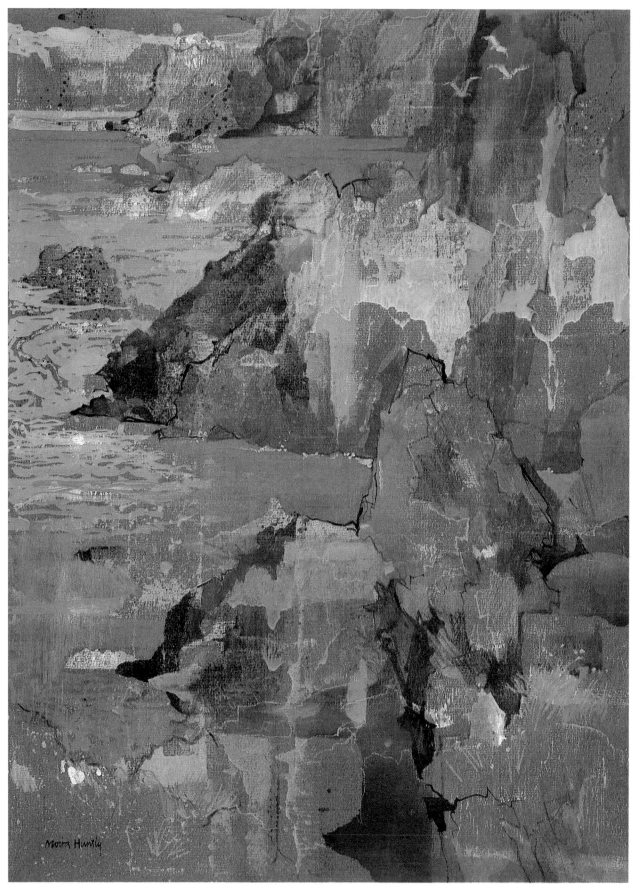

Rocky Coast, Pembrokeshire $19\frac{3}{4}'' \times 13\frac{3}{4}''$

White ink and gouache on black paper

Charlie's Live Bait Place, Campbell River, Canada

This was painted on a piece of black pastel paper and the subject was indicated with a brush, with white ink used at full strength in order to cover the black paper. The area of water in the harbour was painted with white ink diluted with water to give a filmy transparency over the black paper. Colour was added with gouache, applied thickly in parts to cover the paper and broken in parts to allow the black to break through. Most of the solid black areas were left as paper. Finally a small amount of detail was added with an ordinary dip pen and both white and black Indian ink.

These inks are permanent and will not fade and so can be safely used in a painting, but be diligent and carefully wash brushes out thoroughly in water immediately after use.

The combination of coloured paper and contrasting inks, with touches of bright colour, can be used to produce exciting images.

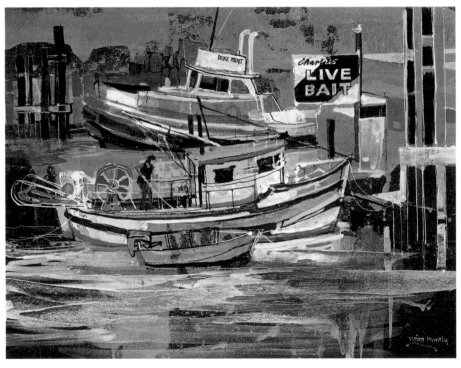

Charlie's Live Bait Place, Campbell River, B.C. $9\frac{1}{2}'' \times 12\frac{1}{2}''$

Indian ink, white ink, watercolour and pastel pencil with masking fluid

Guitarist, John Blockley

Here I have chosen a painting by fellow artist John Blockley and asked him to discuss it. He wrote:

'I had been invited to paint a watercolour with a musical content and decided to do something colourful and not too serious. The subject is imagined – it represents my idea of what a "pop" electric guitar player might look like. I thought in terms of jazzy lights, bright magenta emerging from mysterious darks. The background is rose madder watercolour, painted on to a very non-absorbent smooth paper which resisted the wash, causing the liquid paint to dry rather streaky, and to collect in bubbles which burst to create mottled lights. I painted part of the wash wetter than other parts so that the paint dried unevenly – then I hosed away the still wet parts to create soft-edged light patches.

'I let the paper dry, and with a dip pen dipped in masking fluid I masked out the fringe which decorated his clothing. I imagined that all pop players would be so decorated. Then I washed clean water over the right and bottom of the paper and dropped waterproof black ink into it. In places the ink separated out from the water to make small granules of black, whilst elsewhere the ink dried into the paper as solid black areas. The black in the lower half of the painting suggests the figure, but without explicitly defining it. The hair is black ink, sharp and edgy. I chose black to unify with the black ink elsewhere, and similarly I painted his glasses black– and also of course because all pop players wear black glasses! While the black hair was

still wet I introduced a little rinse of blue tint into it.

'I let the ink dry again and rubbed away the masking fluid to expose the rose madder of the fringe. Then, with white ink, I indicated the guitar.

Finally, with a rose madder coloured pastel pencil I scribbled diagonal lines across the background and stabbed pencil dots of colour into it and into the clothing.'

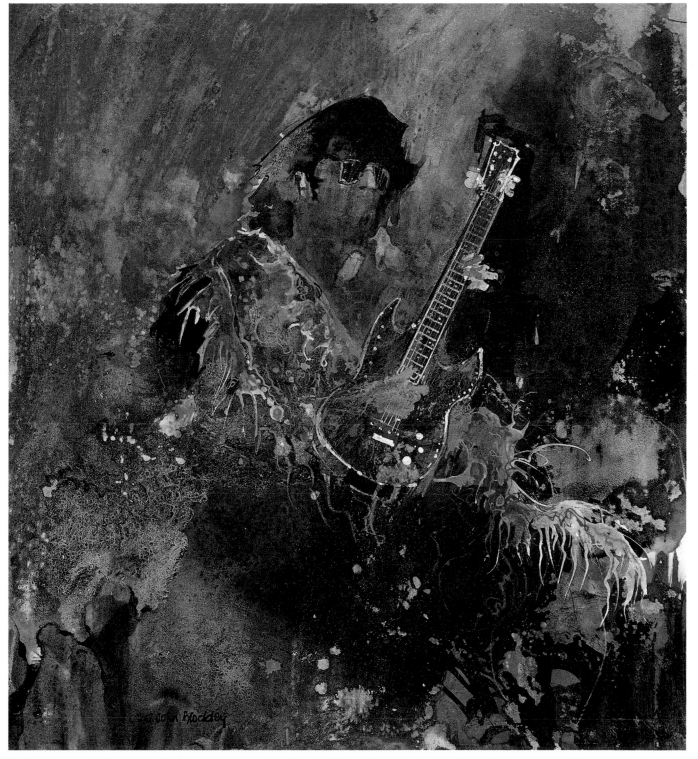

Guitarist, by John Blockley
$10\frac{1}{2}'' \times 9\frac{1}{2}''$

Indian ink with poster paint resist

Here the diagrams show a method of using black ink with white poster paint to achieve a monochrome painting with interesting graphic qualities. The process is based on the use of water-soluble poster paint used as a resist and then removed with water. Poster paint comes in a paste form ready for use but is not guaranteed as a permanent product, which in this instance does not matter since I am using it only as a resist. It has good covering properties, dries matt and is ideal for this mixed media resist technique because the poster paint is thick and prevents ink from penetrating through it to the surface of the paper beneath. At the same time it has the advantage of being soluble in water, which enables it to be washed off under the tap at the end of the process.

For demonstration purposes I have tinted the white poster colour with watercolour so that it shows up against the white paper. Use thick paper or card for this technique.

Fig. 1 The boats are lightly drawn with a simple pencil outline and then all the white areas and lines are painted with thick white poster paint.

Fig. 2 The paint is allowed to dry and then the whole paper covered with waterproof black Indian ink, using a wide brush.

Fig. 3 When this is dry, the paper is laid in cold water and the surface gently brushed or sponged. The poster paint will soften and lift away, taking the ink overlay with it. The ink will remain on the unpainted areas of the paper only.

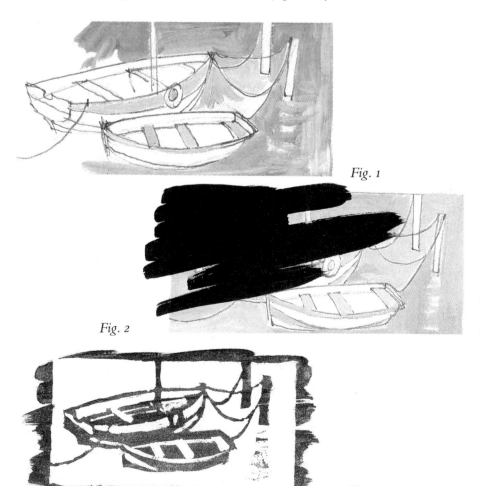

Fig. 1

Fig. 2

Fig. 3

Ink and acrylic with poster paint resist

Gorey, Channel Islands

The painting shown opposite, based on a sketch of a café in Gorey on the Channel Islands, was made with the same Indian ink and poster paint resist technique. This time I introduced colour washes using thin acrylic paint. I based my choice of colour medium on the fact that acrylic paint is waterproof when dry and therefore would not disappear during the washing off process of this technique.

First, I made a light pencil outline of the buildings and then brushed thin washes of blue and yellow acrylic colour over the sky and parts of the buildings. These washes dried quickly and then I applied thick white poster paint to all the areas that I wished to remain white, blue or yellow. This in turn was allowed to dry before I applied Indian ink with a wide brush over the whole of the painting. (It is always a frightening moment when my brush is poised ready to cover the whole of the image with a layer of black ink). Later, when the ink had dried and the painting was placed under a gently running cold tap, there was a moment of relief when the image reappeared like magic. The black ink now deposited on parts of the painting contributes a graphic quality to the image, sometimes unexpectedly in places. Finally I added details with acrylic paint and with pen and ink.

Gorey, Channel Islands $13'' \times 9\frac{1}{2}''$

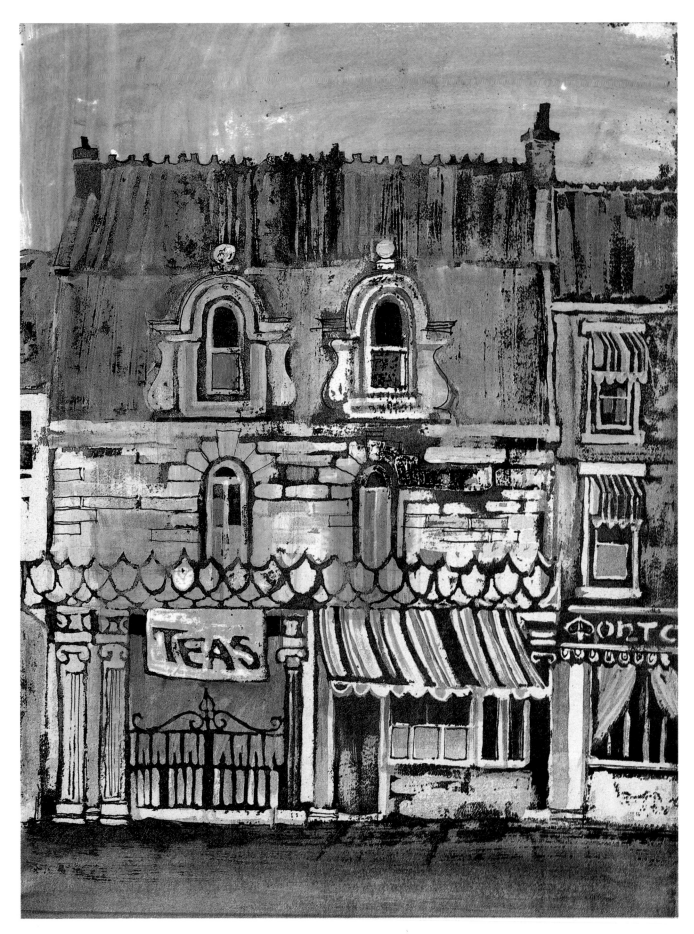

Ink and conté pencil with poster paint resist

Scotch Lass

Very few outlines were used in this ink and poster colour technique version of the harbour sketch. I concentrated my attention on the light-toned shapes and the spaces between the masts, and painted these first with poster paint,. These 'in between' spaces are known as negative shapes and are just as important as the positive shapes, for they are an integral part of a composition. I applied the poster paint with a

Bangor, North Wales

dry-brush technique on parts of the sky and water which allowed some of the subsequent layer of ink to penetrate to the surface of the paper beneath.

Once the poster paint was dry, I covered the whole of the paper with Indian ink and then allowed most of it to dry. Then I immersed the paper in cold water which loosened and washed away the areas of poster paint (and the ink on it) leaving black ink adhering to the unpainted white paper. You will notice that some of the dark areas in the painting are mottled with grey; this occurs where the ink was not quite dry and has been partially washed away, leaving pale stains. A few adjustments have been made to the image by adding a few fine line details with a conté pencil.

Detail from **'Scotch Lass'**

Scotch Lass $10\frac{1}{2}'' \times 13\frac{1}{2}''$

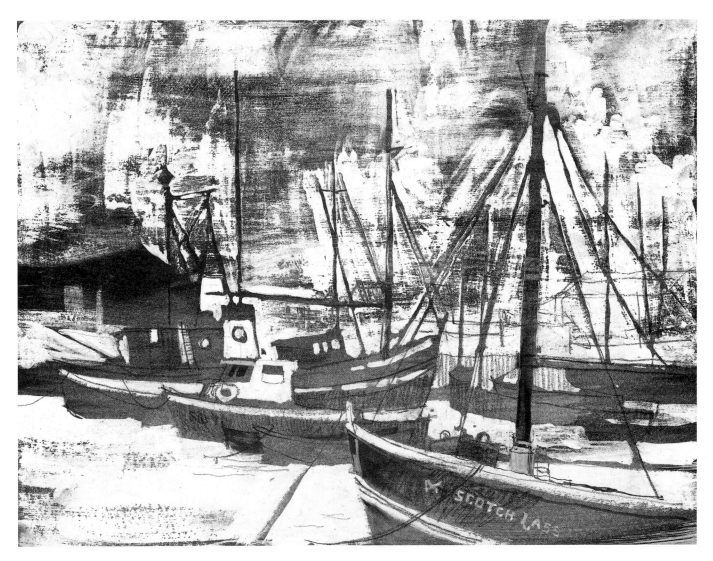

Oil pastel and other media

Oil pastel techniques

Oil pastels, as the name implies, have a greasy quality similar to that of wax crayons. They are firmer than soft pastels and can be sharpened with a knife, and because the pigment is oil-bound these pastels can be used in conjunction with oil paint. Colour can be applied to a variety of supports, with varying degrees of thickness, and soft effects can be achieved by spreading the colour already on the support with a brush or soft rag dipped into turpentine.

A layer of oil pastel can be incised with a sharp knife or razor blade to reveal the support or layer of colour beneath, and where alterations are necessary, areas of pigment can be removed with a palette knife before applying fresh oil pastel. Interesting surface textures can be obtained by mixing the media; a wash of watercolour over strokes of oil pastel will be repelled by the pastel and settle only on the paper, and a wash of Indian ink will partially adhere to the surface of the oil pastel, giving a mottled appearance. I have used various supports for these examples of techniques.

Fig. 1 Mixing the colours on the support. Working dark green into light yellow on cartridge paper, and achieving various shades of mid-green.

Fig. 2 Working a light tone on top of dark colour on cartridge paper.

Fig. 3 Using prepared oil paper and scratching through a layer of oil pastel to the support beneath. The grain of the oil paper can be easily seen.

Fig. 4 Drawing with oil pastel onto oil paper moistened with turpentine.

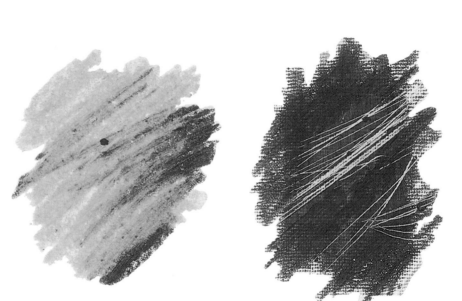

Fig. 1

Fig. 3

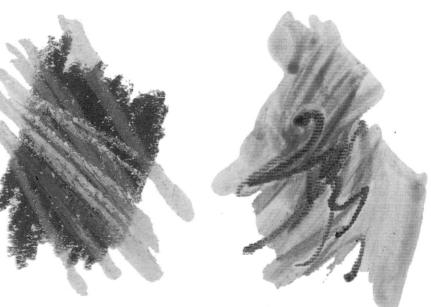

Fig. 2

Fig. 4

Fig. 5 Working into a layer of oil pastel with a turpsy brush on prepared oil paper.

Fig. 6 Orange and green pastel applied to oil paper and then softened and mixed with a brush and turpentine.

Fig. 7 Black Indian ink on water-colour paper, allowed to dry, then a layer of oil pastel applied on top. A thin layer will allow the ink to show through as a dark texture, and a thick layer of oil pastel will cover the ink ground completely.

Fig. 8 Using watercolour paper as a support, oil pastel has been heavily applied over the ink, and then incised with a razor blade, allowing the ink to show through.

Fig. 9 Oil pastel on heavy cartridge paper. Indian ink is brushed on top. The greasiness of the oil pastel repels the ink in places, giving an interesting mottled effect.

Fig. 10 This is a reversal of *Fig. 8*. Using heavy cartridge paper, Indian ink is applied on top of oil pastel, and allowed to dry. A pattern is then incised, allowing the underlying layer of oil pastel to show through.

Fig. 5

Fig. 6

Fig. 7

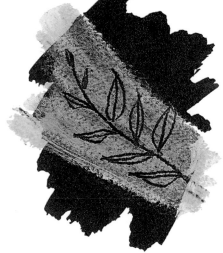

Fig. 8

Fig. 9

Fig. 10

Oil pastel and ink

Still Life by a Window

This painting employs many of the techniques already introduced, such as mixing colour on the support and incising to show the ground beneath, which in this case, with the use of ink, is either black or white.

Stage 1 Black Indian ink has been brushed onto white mountboard, in a bold pattern of shapes with maximum contrast between black and white areas. It is a simple division of a flat surface; the spatial relationships are purely abstract at this stage, leaving me free to develop the subject in whatever direction I may choose.

Stage 2 A still life gradually emerges and strong coloured outlines of oil pastel convert existing curved shapes into the side of a bowl, or part of a fruit. The covering power of oil pastel enables me to make additions or alterations to the initial black ink shapes. For instance, an area of black near the bottom right-hand corner will become almost entirely eradicated in the finished painting. A base of bold colour is crayoned over most of the white area and then refined by working white or pale grey on top.

Stage 3 Oil pastel is gradually built up and then areas are scratched away to reveal the ground. This is particularly obvious in the cut apple seen in the bottom right-hand corner, and also on the tall glass with the handle. Here it can be seen that lines scratched through the layer of oil pastel on black inked areas are black, whereas they are white where the white mountboard has not been painted with ink.

Decorative patterned areas of the painting have been created by drawing with rich brown and burnt sienna oil pastel, and also by scratching with the razor blade. This mixture of media I found very exciting to use, and felt that it lent itself to the creation of a visually interesting surface.

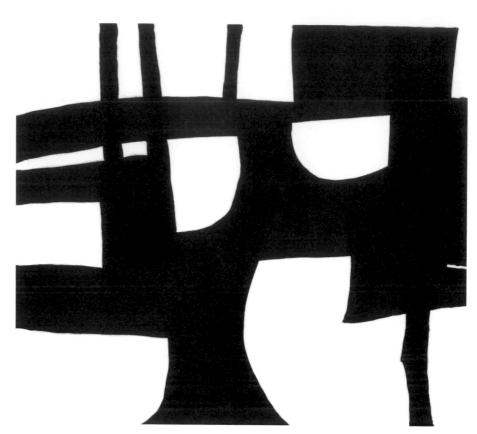

Stage 1

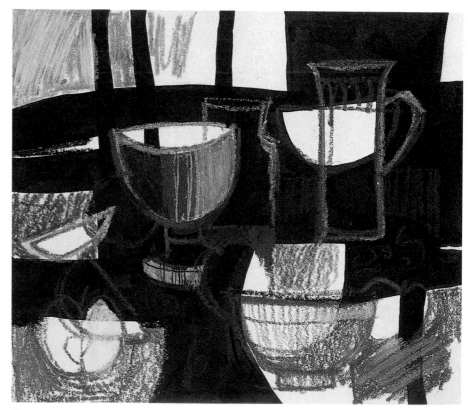

Stage 2

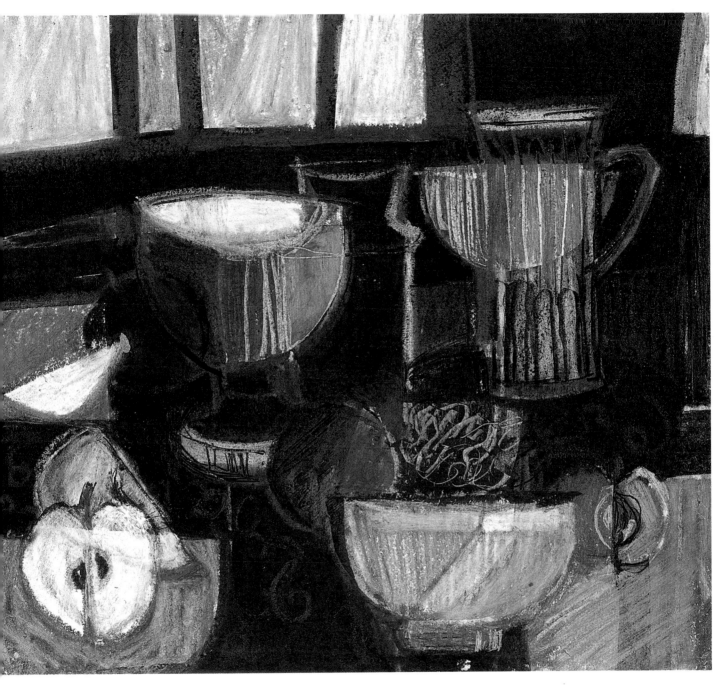

Still Life by a Window $6\frac{1}{2}'' \times 7\frac{1}{2}''$

Oil pastel and ink

Rose and Crown

I covered a small piece of white mountboard very thickly with oil pastel. I used two colours, a pale pink, and a deep tone of orange on the area that was to be a building. Then I used the incising technique and 'drew' the subject with a razor blade. This exposed the white support. The whole of the mountboard was then completely painted over with black Indian ink, then washed off under the tap, leaving black ink in the incised lines. The resultant image has a similarity to an etching. When the surface had dried, I scraped more oil pastel away to produce a few details, such as the light stonework around the windows.

Rose and Crown $8\frac{3}{8}'' \times 5\frac{5}{8}''$

Oil pastel and watercolour

Fig. 1 A dark wash of watercolour on tinted paper is allowed to dry. A light tone of oil pastel is dragged over the wash, giving a broken effect and showing the wash beneath. Where thickly applied, it completely covers the wash.

Fig. 2 Coloured oil pastel has been applied to white paper and then a dark watercolour wash brushed over part. The oil pastel resists part of the wash, but a small amount adheres to soften its effect.

Fig. 3 White oil pastel scribbled over a dark-tinted paper and then scratched through with a razor blade. A dark watercolour wash has been brushed over, giving a mottled effect to the surface of the pastel and staining the ground that the razor has laid bare.

Driftwood

Flotsam can make a good subject for painting, and driftwood in particular can be viewed from all angles to provide an endless number of interesting images. Here I have made use of the textural qualities of oil pastel as a foil to the smoother softness of watercolour. I painted on a piece of thin dark-green Ingres paper, the dark tone of which helped to create the low tone watercolour washes and intensify some very dark areas of indigo in the sky and on parts of the driftwood. After establishing some of the dark washes I used both black and white sticks of oil pastel to draw the subject. Mainly black pastel was used where the washes were of mid-tone, with white pastel over the darkest toned areas.

In applying the oil pastel I employed some of the techniques described in *Figs. 1, 2 and 3*. The light pastel drawing of the driftwood over the dark sky wash was particularly

Fig. 1

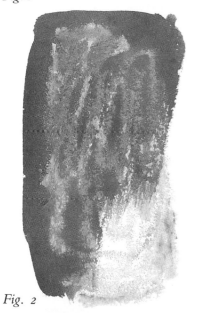

Fig. 2

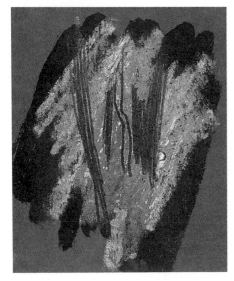

Fig. 3

effective. I then worked layers of coloured oil pastels over the surrounding areas, sometimes onto watercolour washes and in parts directly onto the support. In the centre of the driftwood I applied orange and green oil pastel and touches of gold, creating textures by scratching with a razor blade. These textures were further enhanced by brushing watercolour washes over the pastel.

The painting is not entirely a literal interpretation of the driftwood on the beach; my aim was to create a more dramatic image.

It should be noted that, before applying oil pastel, it is advisable to wait for the watercolour to dry.

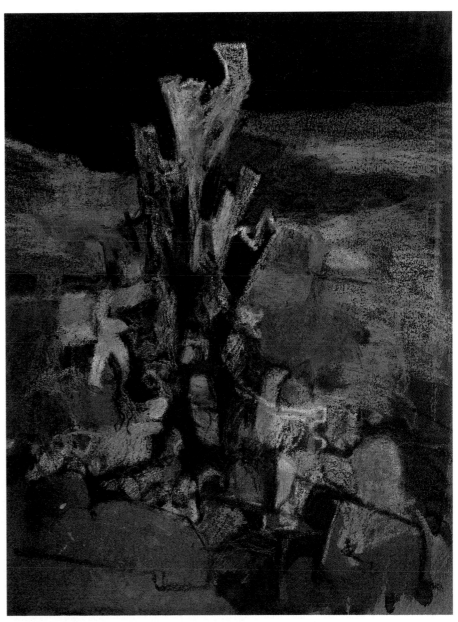

Driftwood $12\frac{1}{2}'' \times 9\frac{1}{4}''$

Saxophones
16″ × 12″

Oil pastel (including gold) and watercolour

Saxophones

I made studies of various instruments with a fibre-tip pen; the curves and variety of shapes required acute observations and were fascinating to draw. The saxophone made a perfect subject for painting with gold oil pastel but was not easy.

The painting that resulted from these fairly careful drawings laid emphasis on the design and pattern of the details and became an interpretation of saxophones rather than an accurate rendering. I used a deep blue-grey Ingres surfaced mountboard as the support, and this colour can be seen in a few small areas of the background and within the bowl of the saxophone on the right.

I began the painting with watercolour, outlining the shapes of the saxophones with a brush and a mixture of indigo and burnt umber; then I added tone with washes of indigo and ultramarine blue, taking care not to soak the support too much and create buckling. When this was dry I crosshatched parts of the background with strokes of blue, green and orange oil pastel, warming and enriching the cool ground. All this preparatory coverage with dark tones produced an effective background over which I could paint the bright pattern of instrument details with two different shades of gold oil pastel. Where the oil pastel has been applied in a thin layer, the texture of the support is clearly seen. On some of the areas where I have applied a thick layer of pastel, I have employed the technique of scraping back to the underpainting with a razor blade. This was especially effective in obtaining the very fine lines of the lettering on the side of the saxophone.

The factual information from the sketches, combined with some imagination and use of mixed media, has created a realistic impression balanced with abstract patterns and shapes. I aimed for a decorative effect of curves, discs of gold and elliptical shapes within a line grid. Finally, a few touches of brilliant turquoise oil pastel were added as a foil to the sparkle of the gold.

Gold oil pastel and white acrylic

Doodles

These doodles with gold oil pastel were inspired by a recent visit to the Middle East. Most of them are made on scraps of dark mountboard and a razor blade has been used to incise the pastel and reveal the support.

Fig. 1 Two shades of gold oil pastel on brown mountboard.

Fig. 2 Gold oil pastel over white acrylic paint on brown mountboard.

Fig. 3 Two shades of gold oil pastel on white mountboard. The subject has been incised with a razor blade, revealing the white support.

Fig. 4 Gold on textured black pastel paper.

Fig. 5 Two shades of gold incised to show blue-grey mountboard.

Fig. 6 Another doodle on blue-grey mountboard.

Fig. 7 A combination of white acrylic and gold oil pastel on blue-grey mountboard.

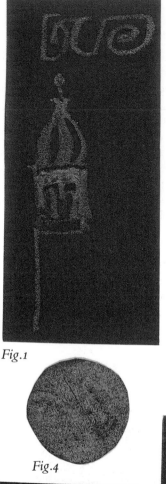

Fig.1

Fig.2

Fig.3

Fig.4

Fig.5

Fig.6

Fig.7

Gold oil pastel and acrylic

Mosque

Here I have used two shades of gold oil pastel on a mainly white ground, sometimes counterchanged onto areas made dark in tone with an underpainting of acrylic paint. Acrylic paint has the advantage that it can be applied as a thin wash like watercolour or thickly as impasto, which is similar to oil paint. This allows for a variety of surface textures to be employed in one painting.

I used a piece of white mountboard, and started with a light pencil outline of this complicated building. Then I brushed a thin pale green acrylic wash over the sky and onto parts of the mosque. Stronger washes of viridian were painted onto the windows and minaret, followed by a darker green tone on some of the domes and arches. The remaining domes were left as white mountboard.

Then came the exciting moment of enriching the painting with gold oil pastel, and I applied the two shades at random onto the domes. I made the application very thick so that I could incise lines through the layer of oil pastel with a razor blade. This exposed the ground beneath, which was unpainted white mountboard on some of the domes and dark green acrylic colour on other domes. Gold oil pastel was also applied to some of the windows and then details were incised.

I wanted to keep the sky simple in contrast to the building, yet give it some substance, so I overpainted it with thick pale-green acrylic paint, allowing the brush strokes to provide a subtle texture. Some of the walls were painted with white acrylic and more textures were created by the addition of a thin layer of oil pastel over the thick white paint on parts of the outer wall of the mosque.

In the final painting the white areas are concentrated on the walls of the upper storeys of the mosque, the domes are all treated with gold, and most of the exposed green underpainting is confined to the windows and arches. This selective use of gold, white and green gives the painting a unity which would have been lost if the various processes had been scattered indiscriminately over all. The whole painting is simple in colour, but embellished with two shades of gold.

Mosque *8″ × 17″*

Collage and other media

Collage and charcoal

Earlier in this century the long-established traditional methods of painting were shaken by artists such as Picasso, Matisse, Gris and Braque who turned to a mixture of media to present their images. New lines of thought emerged, and there was a greater awareness of colour, tone and texture, which could often be expressed more powerfully by experimenting with different media. Collage became an important part of this explosion of visual ideas, and lends itself to a freedom of expression.

In this section I restrict my experiments with collage to the black and white discipline of newsprint and combine it with the soft medium of charcoal.

Woman with Shopping Bag

A Newspaper Collage

Conversation Piece

A commonplace incident of town life provided me with an enjoyable basis for a painting. My information was collected in a sketchbook from which I worked later in the studio. Originally the composition was influenced by the Golden Mean, which is a division of a line or area into proportions that are most pleasing to the eye. It is the impact of the proportions used in the arrangement of the parts of a painting that has most importance.

I started with charcoal on canvas and the drawing is the preliminary for a painting which, at a later stage, could include oil or acrylic paint, in addition to the collage. Charcoal is a useful medium to use in these early stages; dark areas of tone can be rapidly established and alterations easily made by dusting off or rubbing out with a putty eraser. When the composition is established I prevent the charcoal from rubbing off by giving it a spray with fixative.

I have designed the painting to combine the static rectangular shapes of the advertisement with movement in the curved lines and echoing shapes. The figures are part of this pattern, and the shapes between the figures are also important in the overall design. The substantial form of the figure on the left is a key dark in the painting, balancing areas of shadow in the background and dominating the central figure. The figurines on the advertisement on the right were carefully chosen as an amusing echo of the principal drawn figures.

Collage can be used as a meaningful part of a painting as, for example, shown here with the ticket and way out signs and advertisements, and it can be used to make specific social comment. Collage is also exciting in purely abstract terms.

Conversation Piece $17\frac{1}{2}'' \times 14\frac{1}{2}''$

Collage with charcoal and oil paint

Waiting for the Train

Here I show my sequence of working towards the finished painting. Initially I tried to establish the abstract elements in this painting by the early division of the surface into two-dimensional areas of geometric shapes and tonal patterns.

From this simplified beginning I feel freer to develop the painting in whatever direction I choose.

Stage 1 This shows simple linear construction, using charcoal on canvas. In these early stages I often want to change my mind about the direction or position of a line, and I find charcoal useful to work with because it can so easily be dusted off, and alterations made. Once the pattern and rhythm of the composition have been established, I use a fixative spray to prevent the charcoal from rubbing off or dirtying any subsequent collage or paint.

Stage 2 Some of the line work is extended to create solid areas of tone, and some architectural features are beginning to emerge – a lamp post, some decorative ironwork, a station sign, a figure. The reference for these came from a group of sketches I had made on a station platform whilst waiting for a train. Although the painting began in purely abstract terms, the ideas for the subject came from my sketchbooks.

Much of the development in *Stage 2* is, however, still abstract, but suggests realism when seen in association with the described features. I began to add some collage, all of which came from a newspaper, utilising the crossword puzzle page as well as the lettering and images on the advertisements. I experimented with the placing of these cut shapes before finally pasting

them down on canvas with acrylic medium. At this stage the work is still a monochrome base.

Stage 3 Now I began to develop the painting with colour, using oil paint scumbled over some of the charcoal surfaces, so that here and there the charcoal base still shows through. Areas of light-toned paint are soft in colour: greenish-grey, apricot, pale lemon-yellow, then in contrast I added some accents of bright vermilion and warm brick colours.

I completed the painting by strengthening some of the line work and developing the charcoal textures and figure. The drawn figure is an unexpected and interesting contrast to the cut-out figures on the collage. The development of this painting was a balancing act in which I tried to combine realism with abstraction and the texture of the dry medium of charcoal with the more fluid, thicker texture of oil paint. It is stimulating sometimes to break out of the mould after a lengthy period of painting with a uniformity of medium. Painters such as Braque and Picasso led the way in this field.

Stage 1

Stage 2

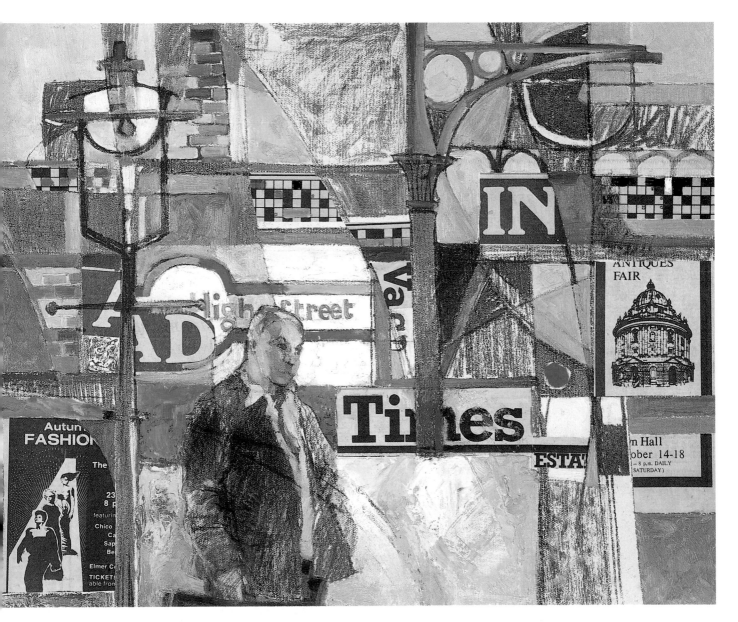

Waiting for the Train $15\frac{1}{2}'' \times 20''$

Using collage as an aid to composition

In this instance collage is being used as a starting point for a painting. Simple shapes have been cut from various colours and tones of paper, and some shapes cut from textured papers. Here I have displayed a few of these shapes, which formed the basic elements for the composition roughs shown on the opposite page. Included are circles, semi-circles, squares, rectangles, and thin strips of paper which can be arranged and re-arranged *ad infinitum*, to provide many ideas for compositions. Use has also been made of the paper shapes remaining after the initial cuts were made.

The pencil studies I have made from the collage arrangements are searching for tones as well as pattern, balance, and spatial relationships. In particular, they bring into focus an awareness of the pattern and shape of the background as having an equal importance in the composition.

The studies provide a step in the development of a composition, and ease the transition from a collage arrangement to making an actual painting. So far they are purely abstract in format, but they can form a vital basis for a painting where the shapes can take on a more meaningful representation. Images come to mind, and I begin to read into these studies subjects such as townscapes, still life, or an interior. Perhaps these arrangements bring to mind totally different subject matter to each individual viewer.

There is no limitation on the subsequent choice of media that can be used to make a final painting. This is also entirely individual.

Cut-out Pieces

Collage with ink, wax and oil pastel

The Black Dog, Vauxhall, London

This collage painting consists largely of paper shapes cut from good quality light-fast coloured pastel paper and from textured papers previously prepared, using the various techniques described on page 124. In the early stages the painting was composed of simple rectangular and circular shapes of varying dimensions, some being almost exactly equal-sided whilst others are narrow and elongated. In fact, the painting contained many of the elemental shapes shown in my earlier composition drawings based on collage.

The idea for the painting developed from the pen and ink sketch shown below, which was drawn on the spot and is a literal rendering of this London pub. The use of flat paper shapes brings out the definite design components of the building; square and rectangular areas of wall, different sized window spaces, and scalloped tops of the walls with their rounded finals. Alongside these relatively flat collage shapes I added details of windows and doors and expressed these in a fairly literal manner with pen and ink line work. The combinations of simple cut-out shapes and intricate detail in widely different media combine to produce an individual interpretation of the subject.

Tonal pattern is important in the painting and I have introduced squares of low-toned sombre colour which highlight the brilliant orange and yellow shapes. This highlighting is also helped by the dark sky on which I used black ink. Just before the ink dried I flooded it with water, which washed away some of the ink to give a mottled appearance. Candle wax was used on part of the road and then washed over with dilute ink. The more solid area of tone on the bottom left-hand corner is a torn piece of ginger-coloured pastel paper with grey oil pastel applied on top. Oil pastels have also been used on the roofs and window surrounds.

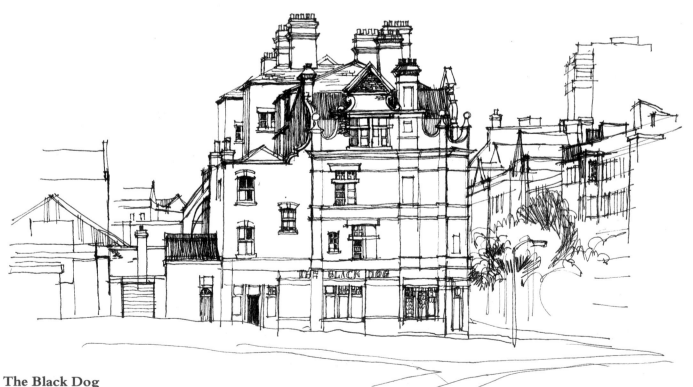

The Black Dog

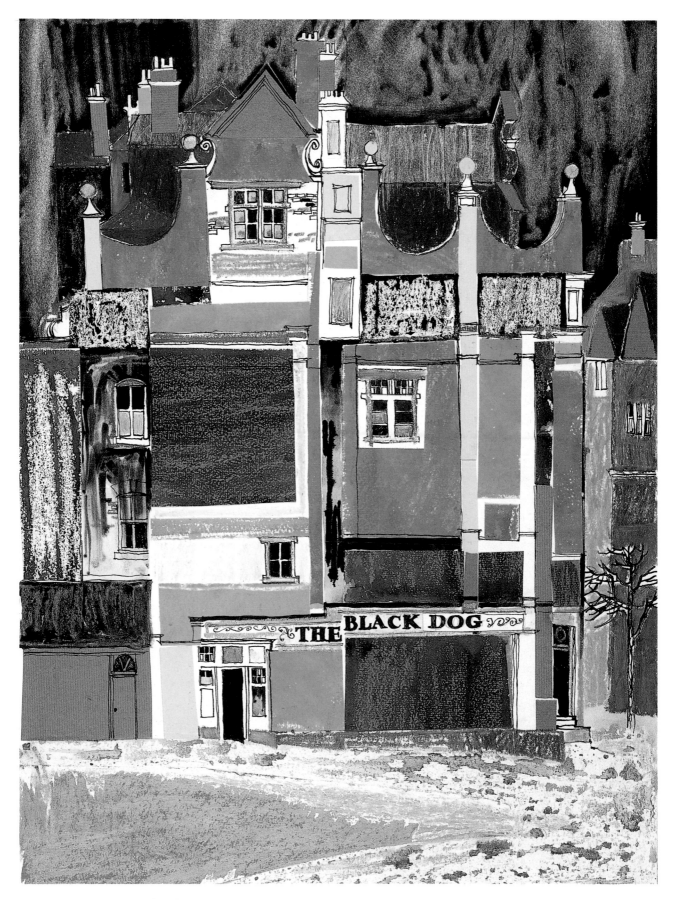

The Black Dog $19\frac{1}{2}'' \times 14''$

Textured papers for collage

These textured papers are useful to have available for collage, and they do not take long to prepare.

Fig. 1 Rubbings made over an uneven surface make good textured papers. This example shows orange and burnt sienna oil pastel rubbed over a piece of heavily textured wallpaper.

Fig. 2 This texture has been achieved by off-setting paint from one surface to another. Cobalt and viridian gouache were brushed randomly over watercolour paper, and before it dried it was pressed down onto a second sheet of paper. When the first sheet was lifted it left an interesting mottled texture on both pieces of paper.

Fig. 3 This started with a wash of raw sienna watercolour on white cartridge paper, and when the wash had dried candle wax was applied in a random scribble. Next I put a wash of Prussian green over the whole of the paper, the candle wax resisting this wash and allowing the first wash of raw sienna to show through. After the second wash had dried blue crayon was applied, followed by a final wash of indigo. This in turn was resisted by both the candle wax and the blue crayon. No white paper is visible, the lightest tone is the colour of the first wash, seen through the first waxing, and the next light tone is the colour of the second wash and so on. In this way the texture develops progressively.

Fig. 4 This time some candle marks were made directly onto white paper followed by a raw sienna wash. When this was dry orange wax crayon was applied and then a wash of burnt sienna. Then more orange crayon, followed by a purple wash and finally an application of purple wax crayon. Any combination of coloured wax crayons and watercolour washes can be tried, and some rich textural papers are created.

Fig. 1

Fig. 2

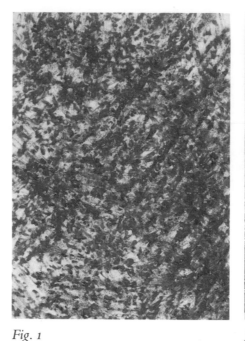

Fig. 3

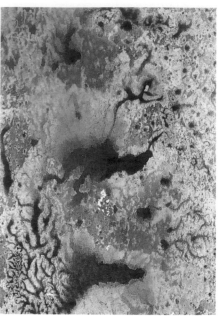

Fig. 4

Tissue paper collage and watercolour

This collage technique involves pasting down layers of white or coloured tissue paper onto a support, and then painting over it with transparent watercolour or a thin film of gouache. The layering of tissue shows through the paint and results in an interesting textural pattern.

Quite often the watercolour washes gather along the edge of the tissue paper in an uneven but pleasing way, and some of the effects can look like crazing.

The layers of tissue can be pasted down in a random manner or alternatively shapes can be considered and arranged in a deliberate order.

Here I have used pieces of coloured tissue on a white support, and because tissue is so thin, it is transparent enough to enable the overlapping of two colours to mix optically and create a third colour. Where pieces of the same coloured tissue have overlapped a darker tone results. These pieces of tissue are a random arrangement, which can provide inspiration for painting

Mountain Range $9\frac{3}{4}'' \times 15''$

The coloured tissue I used for this mountain painting was pasted onto a piece of olive-green pastel paper. This created a more subtle colour mix where the tissure overlapped. Here the jagged edges of the collage pieces reminded me of the crags and peaks of a mountain range. Soft washes of dilute white gouache muted the background colours and helped to create recession within the painting.

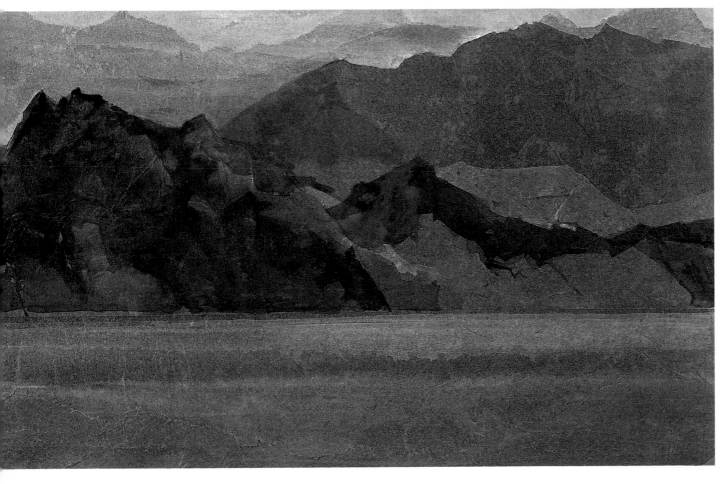

Tissue paper collage and watercolour

Tiger Lilies

The painting of tiger lilies was made on a prepared ground of white tissue collage, and commenced with pale watercolour washes. I pre-mixed the colour in two saucers, one of orange and one of olive-green watercolour, and worked with two brushes, dipping alternately into each colour as the subject took shape. The washes gather along the edges of the tissue paper and dry slightly darker, thus accentuating the tears in the collage pieces. With each subsequent wash the torn edges become more pronounced and create an interesting texture.

In parts of the painting these tissue shapes have been incorporated into the subject as part of a stem or the edge of a leaf petal. I think it is valid to notice and make use of these haphazard occurrences.

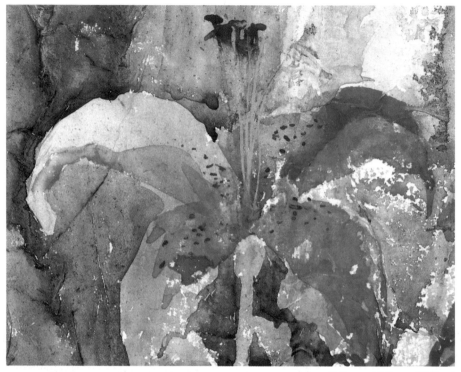

Detail from **'Tiger Lilies'**

Tiger Lilies 15″ × 11″

Pens and pencils (lead, charcoal and conté)

Pant Y Gwydd, Anglesey

The outlines of the buildings, trees, rocks and bushes were made with a fibre-tip pen on white cartridge paper in my sketchbook. I filled in areas of tone with combinations of felt-tip pen, lead pencil and charcoal pencil. The overall result is a pattern of empty white spaces of varying size and of varied tonal density in the bushes and trees. The dark tones are mostly connected together and thread their way through the areas of white paper.

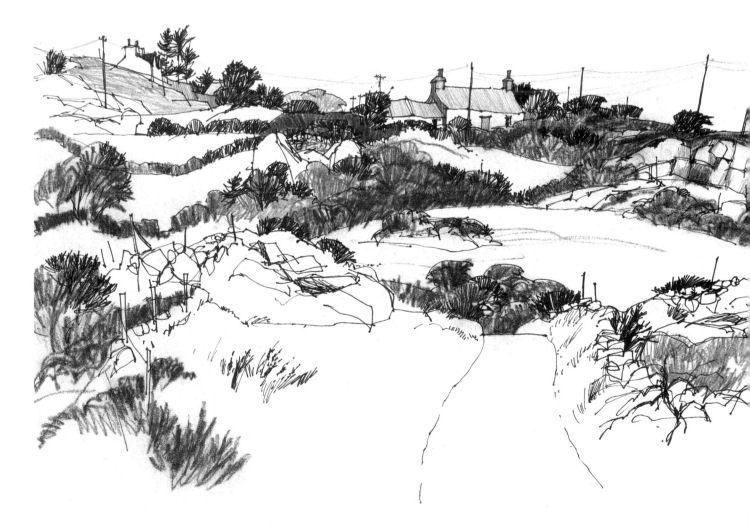

Yorkshire Barn

This sketch was made on buff-coloured pastel paper chosen to be in sympathy with the colour and tone of the stone building. The drawing was started with white conté pencil and firmed up with pen and ink. The rough texture of the stonework was drawn with grey, brown and white conté pencils and the bleached areas of stone were shaded with white conté. Dilute Indian ink was used for the deepest shadows and some of the drawing strengthened with a brush and dilute ink.

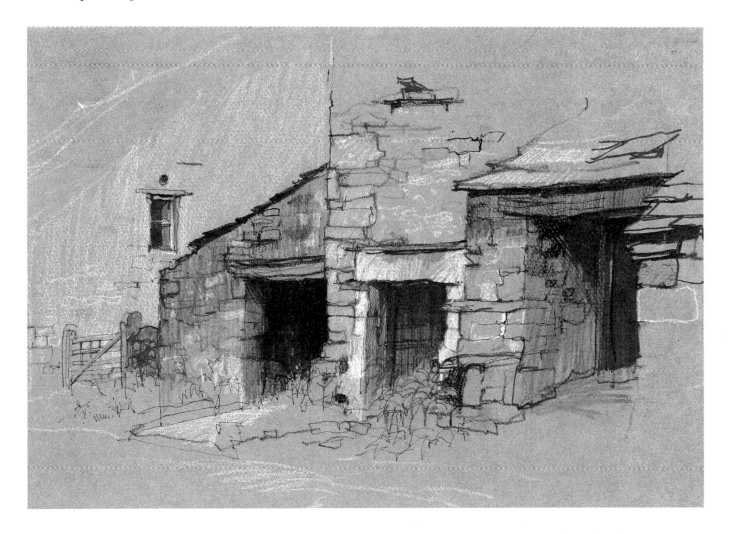

Pens and pencils (lead, conté and pastel)

Halton Gill, Yorkshire

The buildings, trees and structure of the landcape were drawn with brown conté pencil on white cartridge paper. Then the dark tones of the trees were drawn with brown and green pastel pencils reinforced in places with a 3B lead pencil. The dark tones of the trees help to describe the light falling on the roofs of the buildings. Pencil alone was used to indicate the shadow side of the buildings and the tar macadam of the road.

On the hillside some shading was made with diagonal line work, using an old chisel-ended light-grey felt-tip pen almost exhausted of colour. The result delicately blended with the conté pencil lines, so that the tones became quite pale and secondary to those in the trees and foreground.

Horton in Ribblesdale, Yorkshire

Again I have used a combination of lead pencil and pastel pencils. The varying density of line produced by the pencil and pastel pencil are useful in conveying the texture of the stonework. Colour notes have been added sparingly in the sketch, using blue and green pastel pencils to suggest the foliage on the right and echoed on the door. Small areas of colour can be attractive in a sketch when placed against areas of white paper. A sense of direction is suggested in the sketch by keeping a passage of white-toned paper running through from the foreground towards the central house and sky. This white passage is framed each side by the shading on the buildings.

Halton Gill, Yorkshire

Y Fron, North Wales

This sketch started with a sparse light pencil outline, only sufficient to place the principal features. The colour is applied with pastel pencils, mostly in vertical strokes and in places allowing the white paper to show through. Few colours have been used, giving an overall impression of subtle greys to highlight a few light areas on the buildings. These subtle greys were obtained, in fact, by overlaying strokes of quite crude colour and, by keeping the pencil lines fairly open, further colours can be superimposed. Variations in tone on the foreground grass has been achieved by overlapping the same green pencil strokes and not by introducing a darker green colour.

Horton in Ribblesdale, Yorkshire $11\frac{1}{2}'' \times 16''$

Y Fron, North Wales $11\frac{1}{2}'' \times 19\frac{1}{2}''$

Felt pens and charcoal pencil

Caernarfon, North Wales

In this sketch, made with a charcoal pencil, I wanted to record the colour before leaving the site. For this purpose I found that coloured felt-tip pens are quick and easy to use. It should be remembered, however, that the inks in these pens are not permanent and should only be regarded as useful for purposes of recording information.

Caernarfon, North Wales $14'' \times 19\frac{1}{2}''$

Hilliclay Mains, Caithness

Hilliclay Mains, Caithness

I was interested in the long line of buildings and the fence and path leading towards it. I used a different treatment when making this sketch by starting with a pale buff-coloured broad felt-tip pen to block in fairly crudely the shapes of the buildings and the snaking movement in the track.

Then I defined these more carefully with a charcoal pencil drawing superimposed on the felt pen first impression, and not being afraid to alter the positions of some of the features as the drawing progressed. In this case I though that the double image unexpectedly turned out to be visually attractive.

Staithes

Felt pens and conté pencil

Staithes, Yorkshire

This is a fascinating fishing village on the Yorkshire coast with the houses climbing up the hillside and huddled so closely together that close observation was necessary to sort out the individual buildings, especially where their shaded sides merged together. The drawing was made with a black conté pencil and the tones of the buildings blocked in with chisel-ended felt-tip pens. Tiny details were added with a fine-pointed fibre-tip pen. By selective treatment the massing of the darks can be effective in defining areas of building left as white paper shapes.

Staithes, Yorkshire 13″ × 10″

Conté pencil with watercolour and gouache

Staithes, Yorkshire

The drawing was made on white cartridge paper in my sketchbook, using a black conté pencil. I wanted to record the colour quickly so I added some transparent watercolour washes very freely, not worrying about keeping carefully to the outlines of the buildings. Light tones were painted last with opaque paint, made by using white gouache and mixing watercolour into it to make some of the pale colours of the stonework, window paint and roofs. The original drawing was clearly visible through the first washes and so I was able to sharpen the definition as I applied the light tones and touches of light details.

Boats at Staithes

In this second drawing I have used the same sketchbook and the same technique, indicating the boats and harbour wall with conté pencil and covering the drawing with blue and warm grey washes of transparent watercolour. The washes were dark in tone, as this particular subject required. They dried quickly in the outdoor air and I was able to give some precise definition to the boats by drawing with a fine brush and white and blue gouache. Finally some of the dark-toned areas were strengthened with watercolour.

This combination of mixed media for sketching suited this particular subject where the light tones were minimal and required thin lines. It would have been laborious and taken a long time to have painted around all the light areas in order to leave them as white paper. I simply brushed dark tones right across all the drawing, reinstated the details, and created the light tones with opaque paint afterwards.

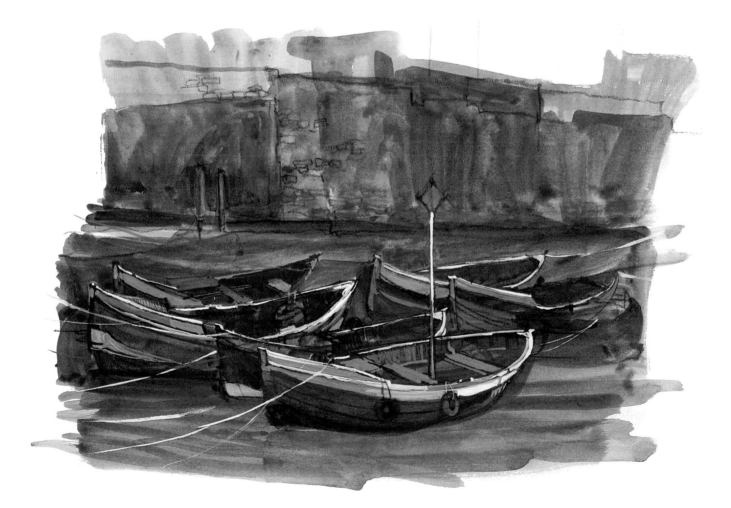

Boats at Staithes, Yorkshire
9″ × 13″

Charcoal pencil and gouache on strongly-coloured paper

Tree on Green Paper

Sometimes I like to experiment and draw on bright coloured supports, so I thought it would be fun to choose to draw a tree on a brilliant green paper. The result was surprisingly effective.

Trees on Wine-coloured Paper

Taking the colour experiment a stage further I decided to sketch what seemed like a whole forest of trees, onto a very dark wine-coloured pastel paper, and add gouache paint. It became clear as I worked that the choice of ground colour has a very strong effect on the colour introduced.

Stage 1 shows the initial sketch made with a charcoal pencil. Even the neutral colour of the pencil seems to take on a green tinge against the deep red colour of the paper.

Stage 2 I chose to paint in gouache because the support was dark in tone and the opacity of gouache provides good covering power. However, the initial tonal washes to strengthen the trunks of the trees and the undergrowth were thinly painted and allowed the drawing to show through. I found to my surprise that my first colour washes appeared much too bright on the paper, consequently I had to adjust my colour thinking considerably, and in fact the colours that I finally used were muted greys, using a palette restricted to black, white, yellow, grey and touches of raw umber.

The sky is mostly white with a hint of yellow applied opaquely in parts to obliterate the colour of the paper, and thinly in other parts so that the wine colour shows through the paint, giving a mauvish tint. The plants in the foreground are mostly combinations of yellow, pale grey and white gouache.

Tree on Green Paper $15'' \times 20\frac{1}{2}''$

A great deal of the painting procedure consisted of filling in the spaces between trunks and branches. This is evident in the sky where the light paint emphasises the pattern of gnarled twisted trees which attracted me to the subject in the first place.

I have deliberately left the painting unfinished so that some of the preliminary drawing is still evident, and this shows my sequence of working. At the stage shown here there is still too much of the wine-coloured ground showing, especially in the immediate foreground and on the right of the painting. To complete the work, I will add more gouache paint and coloured pastel pencil details, confining most of the paper colour to the branches and roots.

Stage 1

Trees on Wine-coloured paper 15″ × 22″

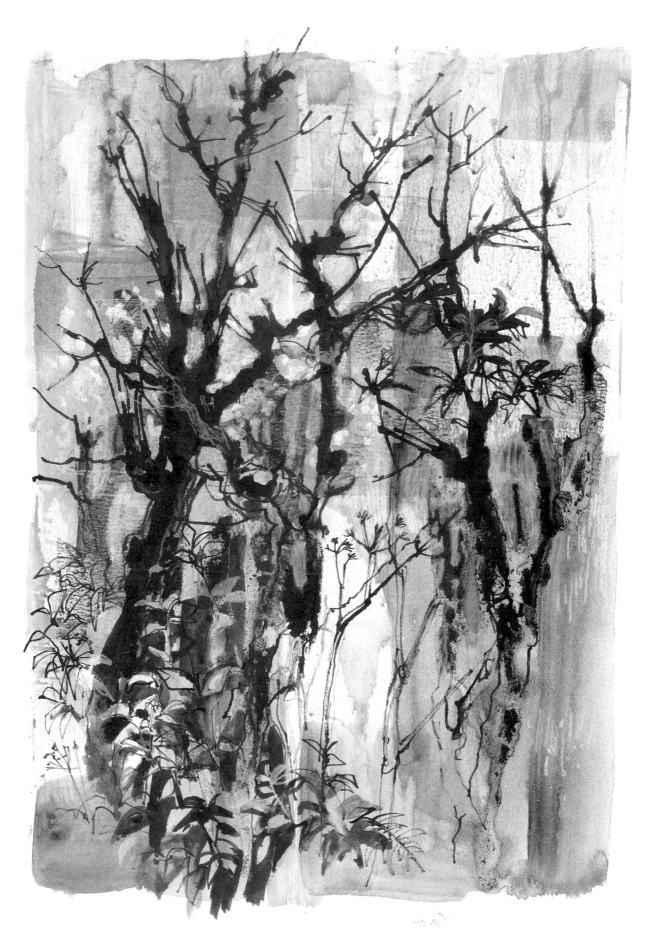

Conclusion

I conceived this an as 'ideas' book, to be dipped into from time to time, and hopefully to help stimulate your repertoire as an artist.

Whatever level of painting experience you may have reached, it is always good to ring the changes, and this is so much easier today, for there is a vast choice of media available to us. For me, experimenting with mixed media has been a voyage of exploration, during which I have made discoveries in techniques previously unknown to me.

Although most of the ideas suggested throughout the book are not entirely new, they may be new to you personally, and so perhaps you may be tempted to embark on a phase of work that requires courage but which, at the same time, can inject vitality into your painting.

Whatever mixture of media you may try it should feel right for you, for painting is a continual struggle to be in command of both the media and the surface on which we work. If, by experiment, you find a way of working that suits you, it can lead to success in expressing yourself.

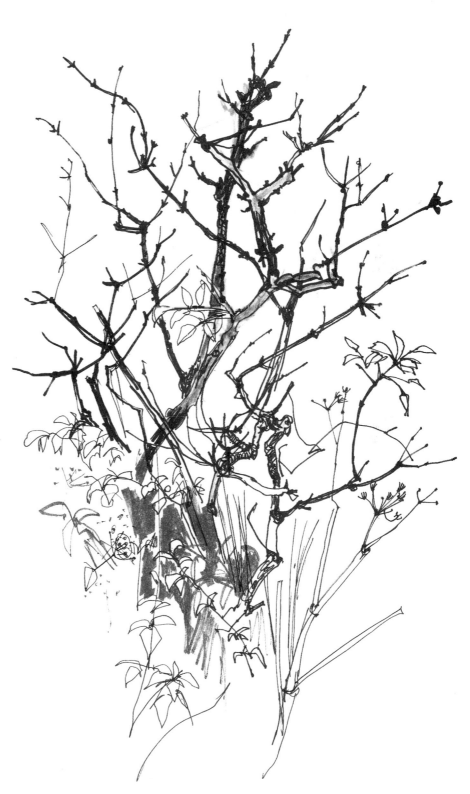

Hedgerow Tree
$12\frac{1}{2}'' \times 8\frac{3}{4}''$

Index